Learning to Draw
Drawing to Learn

Martin John Garhart

DENVER, COLORADO

This book is dedicated to all the students who took my Beginning Drawing Class. They helped me to understand how one can teach anyone to draw. And especially to my partner Cynthia Garhart, whose encouragement and editing have made this task doable.

Preface

This book is based on the premise that drawing is a visual language and, as with all languages, it is learned best through usage and when it has a distinct purpose. To that end this book is structured, in content and format, in a way that promotes both learning to draw and learning to use drawing as a tool for exploring, interpreting, communicating, and understanding ideas, ideas that come from the fabric of the life of the drawer. Each chapter involves the development of drawing skills and compositional considerations as they relate to and develop the visual exploration of ideas that generate from the presented concepts.

Reference Section

Chapter Nine is a reference section. The chapter covers a group of important drawing considerations, fundamentals that the drawer will want to reference repeatedly throughout the book.

Introduction

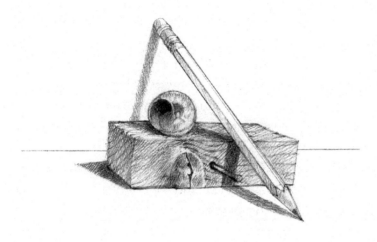

To Draw

To draw is to put a face on the experience that is our lives. To draw is to describe what we are not, in order to understand what we are. To draw is to establish where things are, in order to understand our relationship to them. To draw is to give a visual presence to our inner voice, the voice that wonders, the voice of expression.

To Begin With

You are beginning this drawing experience at a time when most of what we think we know comes through some sort of intermediary: the internet, television, radio, magazines, newspapers, or from another person's account based on the same sources. We are becoming less and less the source of our own knowing. Drawing is one way of regaining

that authority. To that end you are asked to make very thoughtful choices as to what you will draw. Think of each drawing as a lens that is focused on some aspect, no matter how small, of the life you are living, the one you actually know. This does not mean that we cannot embrace the technological world that we live in, to the contrary, learning to draw is a means of better understanding, using, and being a part of it.

Choices

The moment that we start a drawing we are confronted with a series of choices: practical choices, like what materials to use, personal choices, like what idea to work with, esthetic choices, like those of composition and accuracy. Some of the choices will be made for you by the specifics of the drawing assignments but for the most part the choices will be yours and because the integrity of your choices becomes the quality of your drawing, we need to take a look at some of the considerations that go into the deciding.

The first choice is always one of caring. As children we were fascinated by our immediate world, and even though we were probably not conscious of it, we devoted ourselves to describing it and trying to understand our relationship to it. Yet, each moment is new for us, and to be present in our own lives we need to be like children, enchanted by the immediate. It is all we can really know. Our drawings need not answer the philosophic questions of the universe but they can describe and explore our thoughts about it. The drawing assignments in this book will help you stay focused on precisely that, "a fascination and curiosity about the life you live." Simply stated you will be asked to derive the ideas for your drawings from the things, events, and wonderings that accompany you in your everyday life.

You are the authority on your own life

You are at any moment of your life complete and your experiences, both mental and physical, are uniquely yours. In the billions of humans that have occupied this planet none of them have or will experience existence in the same way as you. No one can live your life for you and the responsibility for trying to understand its meaning is all yours. One

of the main objectives of the assignments in this book is to make drawing a tool you can use for that task.

In the drawing assignments you will be asked to develop ideas within specific categories of human concern. These categories represent universal human issues but the idea you choose is yours, so look for your ideas in the fullness of your own life.

There is no external hierarchy of ideas or the stuff of a drawing. You will want to choose subject matter that interests you. One draws best when it is an act of interest and curiosity, when the wonder of it all is before you and when you are driven by the possible outcome of your effort.

Integrity

Integrity at the personal level is simply being honest with ourselves. Only we know when we have invested ourselves fully in a particular effort. Caring about what we are doing, keeping ourselves focused on the task, and being disciplined in our activities is the integrity of effort. Integrity of effort is at the very core of learning.

Risk

To learn is to grow and to grow we must be willing to be off balance, out of control, and vulnerable. It is risky. We are children again taking those first steps, from one hand to another, teetering, often falling (failing) but with persistent effort we do reach the next hand (understanding). Learning is a process, and it is marked by our movement from one level of understanding to another and each step involves risk.

In drawing risk can be as simple as erasing a line that is ok because we know there is one that is better. We risk losing the line that was ok and not being able to retrieve it if our next attempt does not meet or surpass it in quality. But risk also presents the possibility of finding that line, the line that perfectly defines our observation and/or our expression.

Or risk can be as complex as choosing to develop ideas that are new for us. If we simply do "what we do," we never go beyond ourselves. But if we embrace the risk involved in the pursuit of ideas that are new to us, we can learn and grow.

To Learn

Learning is a peculiar activity because it is something that no one can do for us, nor can we do it for anyone else. Learning is the act of putting who we want to be up against who we are.

The first step in learning is the desire to learn. The desire to learn is basic to being human. You have this book because you want to learn to draw and to learn to use drawing as a tool for thought.

The second step in learning, and one cannot proceed without it, is to say "I can" and believe it. This may sound simple but it is not. It is believing the "I can" that is difficult and especially with drawing, not because it is any more difficult than most things, but because given the misunderstandings that persist about drawing, you have probably already either been programmed to say "I can" or "I can't." **You can.**

The third step in learning is to recognize that by definition, learning means that what is to be learned is new to us. **Learning is the rigorous part of curiosity**. We want to know. And we can celebrate each new understanding as ours, no matter how many times it has been understood by others before us. Knowing this allows us to approach each new challenge with unbridled enthusiasm and with the knowledge that each discovery is ours.

Note:

The "you" that learning, and the theme of this book, is based on is <u>not</u> the self-centered self. It <u>is</u> the self that realizes we can and want to be more. It is the self that understands that learning is a personal process that begins within and from the core extends outward. It is the self that understands that the better we know ourselves the more we have to offer. It is the conscientious self.

Table of Contents

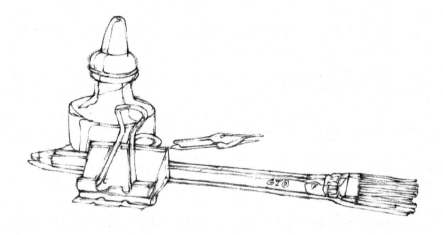

Chapter 5: Line, Shape, Value in transition
(Scumbling Blending) and a Statement of Personal Preference 96

Chapter 6: Line, Shape, Value in transition
(Crosshatching, Stippling) and the Gift ... 115

1

Learning

IN THIS BOOK you will be learning to draw and to use drawing as a tool for thought. From our thoughts, experiences, and observations we collect ideas. In an attempt to understand and to express what they mean to us, we focus and work on the ideas that we find relevant and interesting. It is one of the ways that we grow and put purpose into our lives. We are thinking and communicating in order to learn about and to share these lives we are living, and language, because it encompasses both thought and expression, is the tool for this task.

The Visual Language of Drawing

The visual language of drawing, like all languages, has its symbols and structure. All language is a collection of sounds and/or symbols that, through structure and consistent use, reference and communicate the vast array of human thoughts, observations and experiences. Language is an abstraction, it is not the thing it refers to, it is the line that connects one person's thought about it to another's. In the visual language even the most realistic image is an abstraction, it is not the thing drawn, it is a collected set of markings (symbols) on a surface that creates an understandable reference to what is seen. In the verbal language, letters (symbols) are put together to form words that are arranged to create, through consistency, an understandable meaning. In the visual language of drawing these symbols are the visual elements: line, shape, value, form, texture, and color.

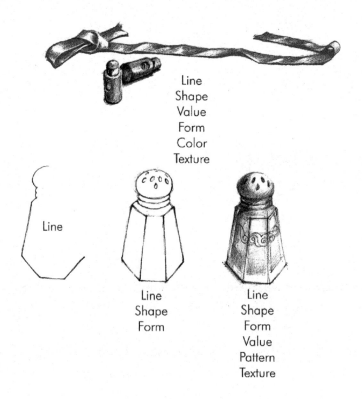

Line
Shape
Value
Form
Color
Texture

Line

Line
Shape
Form

Line
Shape
Form
Value
Pattern
Texture

Ideas and meaning are developed and expressed in an image through the visual language by: what is drawn, how it is drawn, how it is arranged, and what it is drawn on. The image is being created through the craft of drawing's visual language, a language that is based on perception, seeing. The craft is the tool, idea development is the work, and learning is the result.

Note:

Learning to draw accurately what one sees is basic and the foundation of drawing. It gives the drawer the tools and confidence to go beyond oneself.

Learning

In drawing, learning takes place in three ways. There is: learning to draw (the craft,) learning to use drawing as a tool for developing ideas (visual thought), and learning from the finished drawing (the understanding).

Note:

One can learn to think visually and drawing is the perfect discipline for that journey. All journeys start at the beginning and that is where this book will begin. To learn to use drawing as visual thought one needs to learn how to use the basic tools of the discipline. The path in learning is shaped like a mushroom. At the base or beginning, the path is narrow and specific, but as its moves up it becomes wide with possibilities. But if the mushroom is turned upside down, that is, if there is total freedom at the beginning, it becomes very difficult to develop the tools needed to go beyond oneself, making the possibility for growth slight, narrow, or impossible.

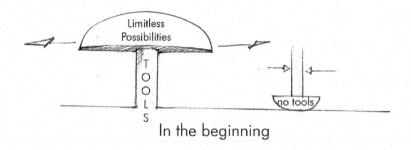

In the beginning

In this book the specifics of drawing's craft will be covered systematically by the assignments that are presented in the chapters. The assignments are based on the learning principal that language is best learned through usage. Almost anyone who has studied a foreign language will say that they learned the most when they were in that country and they had to use it. Its purpose, thought and expression, was clear. The same is true of drawing. The craft of drawing is learned best when one is drawing to visually develop and express their thoughts.

Note:

Learning to draw and drawing to learn go hand in hand, and depending on where we are, they lead one another. There are times when the development of an idea will require that we learn more about the

craft and there are times when a development in our craft suggests new ideas. Our ideas and our craft are growing together and from each other. This is not only true for the beginning drawer, it has been true for artists, at all levels, throughout time.

Thought and Expression

In drawing, as in writing or conversation, thought and expression grow together. They are, in fact, head and tail of the same animal and there is really no clear way to separate them. They intertwine and are for the most part indistinguishable from each other. It is, however, helpful to consider them separately.

Thought:

The conscious activity of thought is thinking. Thinking is the effort one makes in order to take an idea into an understanding that goes beyond what was previously known. The understanding is new to the thinker, something has been learned.

As thinkers, our thoughts revolve around making sense out of, and putting meaning into, this life we are living. At their core, our thoughts are about **describing, differentiating, questioning**, and **celebrating**. These are basic human issues and the images that arise from the ideas that they generate appear consistently in the works of visual thinkers, from those inscribed on the walls of caves, to those being currently exhibited in galleries across the country. The specifics of the ideas are unique to the time, place, and the individuals, but underneath these ideas, their foundation, is the describing, differentiating, questioning, and the celebration of this situation we call life.

Describing is a way of knowing what things are, factually. In drawing, it is their visual characteristics. Describing is a means of better understanding the subject's, and our, presence in this world at this time. When we describe we are using language to explore and express our relationship to the subject and its relationship to us. To describe is to differentiate. Differentiating is our acknowledgment of another presence; the ways it is like us, the ways it is not, the ways we think about and

interact with it, and it and our relationship to everything else. To differentiate is to realize that we are unique and at the same time connected to the whole, an understanding that generates a multitude of questions. The questions we look for give meaning to this one life we know we have, and help us celebrate and acknowledge the ultimate mystery and miracle of it all. We are trying to understand what it means to be "here" and to be "me."

Expression:

With expression, ideas move from the mental activities that occur in our heads to something that exists outside of ourselves. The moment the drawing begins, expression starts. The idea now has substance, from the first mark made to the finished drawing, it is both ours and its own entity. The idea is born and it is our responsibility to nurture it with integrity, that is, to make the considerations about it as high in quality as is possible for who we are at that moment. If we do so the original idea will grow, like a child, into a finished drawing that is our expression and at the same time independent. It is an idea of ours that developed and grew, through the drawing process, into an image that expresses a meaning that is new for us, a new understanding. The drawing is now our expression of that understanding.

Note:

The meaning of a visual image is not a formula that has only one answer. The visual language is more like poetry where much is left up to the reader's interpretation. An image is like a mirror where what is reflected depends on who is looking in to it. However, it is not an empty mirror, an image has visual information, chosen by the image maker that sets up the parameters of interpretation.

The Four Stages of Idea Development

Idea development encompasses four distinct learning stages: **the idea, the drawing process, the finished drawing,** and **the public critique.**

The Idea:

Ideas come from our mental and physical selves, they are about the tangible: people, places, and things, and the intangible: feelings, questions, and beliefs that spring from the activity of life. Ideas are unlimited and as unique as we are as individuals. That is one of the wonderful things about being human, but the unlimited quantity of ideas also makes it hard to know where to start. Nothing is any more immobilizing than infinite choice. For this reason it is helpful to find a way to narrow the choices. In order to do so this book will separate ideas into three basic categories: Realistic, Formalistic, and Fantastic. These categories will serve as lenses that narrow the choices and bring a particular aspect of the whole into focus.

In order to better understand the categories we need to first consider Formal and Narrative Focus.

Formal/Narrative Focus

In language there are two basic considerations: what is being said, the **narrative** content, and the way the language is put together, the **formal** structure. In the visual language that translates into "what it says," its narrative, and "how it looks," its formal structure.

As image makers we need to understand and take charge of these two components and to do so we need to consider them separetely.

Note:

When considering the Formal and Narrative choices for a drawing one wants to give priority to those that support the focus of the idea. Ultimately, however, the objective is to make both the Formal and Narrative aspects of the drawing as strong as possible.

Narrative

All images say something, they have meaning, some very intentional, some not, but if it can be seen it will provoke meaning regardless of its style, subject matter, or even the total lack of subject matter.

Formal

All images are an arrangement of, some or all, the visual elements. The visual elements (line, shape, value, form, texture, and color) are the voice of the image, the things that give it a visual presence. To create an image they must be assembled in some fashion. How we chose to make, use, and arrange them defines the purely visual, how it looks, aspect of the image.

Narrative/Formal

Separating the Narrative and Formal aspects of our drawing is an intellectual activity, they are inseparable, but we do so in order to understand our intentions and to give a priority to our choices. All drawings have both Formal and Narrative qualities, but in developing an idea one of the two is the primary focus of the idea. An idea that is being developed primarily for its potential meaning, what the image "says," has a Narrative focus. In a drawing with a narrative focus priority is given to choices that will support the developing meaning. The Formal aspects are chosen to promote and support the development of that meaning.

With an idea that is based on developing some aspect of the image's visual character, how the image "looks," the subject is the Formal. Priority goes to the choices that enhance the development of the visual characteristics that encompass the idea. The Narrative potential of the drawing's content is considered and priority is given to those that enhance and do not interfere with its visual focus.

Given when developing an idea visually one must consider both its Formal and Narrative potential, each category of ideas that will be used in this text will lend themselves more to one or the other.

Idea Categories

Realistic ideas are about the content of our day-to-day life. They are ideas that become Narrative drawings that explore our personal and social selves and the way we are experiencing life as both observer and participant.

Fantastic ideas are about our imaginings. These ideas arise from our

need to give substance to the unknown and or the seemingly impossible. They are Narrative drawings that are developed from ideas that are generated in the wondering of our imaginations.

Formalistic ideas are based on the purely visual. They are ideas that are based on exploration of the visual elements and the way they become the focus of the drawing.

These categories are simply doors and where you take them is a personal journey. Once you have settled on an idea to develop you are ready to begin the drawing process.

The Drawing Process

The drawing process is a conversation, a conversation between the drawer and the drawing.

The Conversation

There are, in our lives, those individuals who when we are together and talking, the talk soon becomes a conversation. Talk becomes a conversation when our responses to each other come from the understandings that arise from what is being said and not from what we individually already know. We are using language to think together. We are both going beyond ourselves and when we leave a conversation we are different people, we have grown.

The same thing can and should happen in your drawings. It starts with the ideas, the "what ifs." They are a starting point and, by necessity, a conversation with ourselves. Through a series of small studies, thumbnail sketches, an idea is chosen. At first the drawing is dependent on what we know, the original idea, but the moment we make a mark on the paper we begin to make choices. We have to respond to that mark by seeing it and making choices based on what we see. If we are open and responding to what we see, and not dictating, at some point the drawing begins to breathe, take on its own life, and the conversation begins. We draw, look, and make choices based on what we see. Our drawing is now reflecting each new choice and each new

choice demands a response and each new response takes the drawing to a new level. Our response may be as simple as changing a line or as major as following a new narrative. We are thinking visually, drawing to learn.

In the drawing process, once the **Idea** to be developed is selected, the considerations and choices are made with respect to the components of drawing's visual language: what is drawn (**Subject Matter**), how it is drawn (**Marking System**), the way the marks are made in the marking system (**Marking Gesture,**) the way it is organized (**Composition**), the devices used (**Media** and **Tools**), and the configuration of what it is drawn on (**Format**). Each one of these considerations interact with each other in the making of the drawing and it is our responsibility to orchestrate the interaction. That orchestration is the drawing process.

Subject Matter

After an idea is decided upon, the next choice is what to draw, the subject matter. Subject matter moves our thoughts from the ephemeral to the concrete, it gives the ideas a reference of substance.

Note:

Although subject matter can come from a wide variety of sources, including total invention, in this book you are going to be asked to choose subject matter that can be seen, the actual thing. You are going to be drawing from the fact. That way no one else is making drawing choices for you, and drawing from the actual subject matter is the best way to learn the craft of drawing.

We chose subject matter based on how it looks, its formal attributes, and its narrative potential, depending on the needs of the ideas we are exploring.

With Formal ideas the choice of subject matter is based primarily on its visual characteristics, its shape, texture, value, and color, depending on the idea being explored. We want to choose the subject matter that exemplifies the visual characteristics that are the focus of the idea

while remaining as neutral, as is possible, in narrative so that it does not overly compete with its visual intent.

With Narrative ideas, while the visual characteristics of the subject matter are very important, the main concern is with its potential meaning in the image. Some narrative ideas have a foot in the actual world and choosing subject matter for these ideas, while needing to be made with care, is fairly straightforward. A drawing that is based on a descriptive idea like "this is my favorite room" makes the choice of subject matter apparent. While an idea that is more ephemeral like "this room make me feel so" requires subject matter that is chosen for its ability to infer or suggest the meaning.

All subject matter can have meaning. Its meaning can be very clear or it can be very subtle. A heart-shaped box has a very clear meaning, but what a tightly folded piece of paper might mean is much less apparent. A heart-shaped box is a part of popular culture and needs no clues to establish its meaning, it is explicit. A tightly folded piece of paper's meaning has to be established by context: where it is, what is around it, the kind of paper, etc. Its meaning must be implied, it is implicit. All subject matter has either or both explicit and implicit content depending on how it is used in the drawing.

The choice of subject matter is based on its visual characteristics and its explicit/implicit possibilities as they relate to the idea being developed.

Marking System

The marking systems are literally the way the visual elements (line, shape, value, texture, form, and color) are made and used on the drawing surface in order to create an identifiable illusion. They work in a manner that is similar to the way the letters of an alphabet, in spelling, are collected to form words that have a recognizable content. For example, in spelling C- U-P, in English, there are three letters that make sounds that reference speech, and through consistent usage, carry the connotation that brings us the object.

In order to be "readable" a marking system needs to be consistent and have a degree of accuracy in its interpretation of sight. The first marking system, for example, uses line and shape to translate the object's visual characteristics.

First we draw a line into a shape that accurately describes the outline (major contour) and proportions of the cup. Second, we notice every shadow and highlight that falls on the cup and each highlight and shadow can be translated into a shape. Then with line we draw those shapes inside the outline (minor contour) at exactly the position that we see them on the cup. When these shapes are drawn accurately, and the marking system is consistent, they will reference the visual phenomenon of sight and "read" as a cup.

Line and Shape Marking System

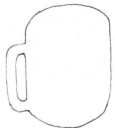 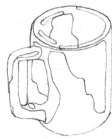

Outline and Basic proportion Shape of Highlights, Shadows and Reflections added

You will learn to use the three primary markings systems and their seven variations. Each marking system has its own technique and uses specific visual elements. The marking systems are defined by the visual elements they use to create a three-dimensional illusion. They share properties, build upon each other, and become more complex as the book progresses. Each marking system is also independent and complete in and of itself and has characteristics that give it its own unique voice. Some marking systems are more formal, almost mechanical, while others are more personal and express more of the drawer's individuality.

The Markings Systems

Line and Shape *(with two line variations)*

Line is used to accurately draw, as observed, the shapes that define the major and minor contours of the subject matter.

Line and Shape
(Objective Line)

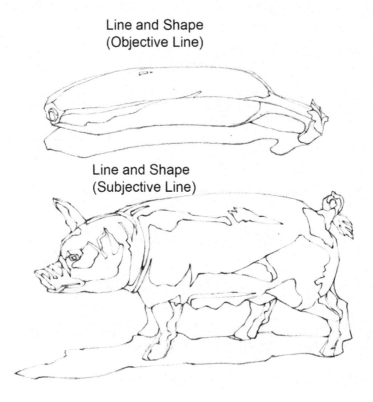

Line and Shape
(Subjective Line)

Line, Shape and Value *(with two variations for creating value)*

A sketched line, searching line, is used to accurately draw the shapes of major and minor contours. These shapes are then defined, as observed, by their corresponding value (lightness or darkness). The line may or may not disappear, absorbed into the value that defines each shape.

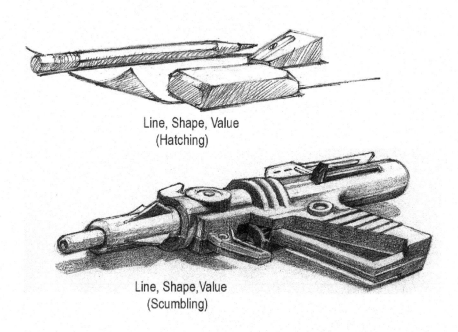

Line, Shape, Value
(Hatching)

Line, Shape, Value
(Scumbling)

Line, Shape, and Value in Transition *(with four variations for creating value)*

A light sketched line is used to accurately draw the shapes of the major contours. Then a gradation from light to dark or dark to light (value) is drawn to create the illusion of the observed volume. The illusion of volume occurs because the light values appear to come forward while the dark values appear to recede. The rate of change, as the value goes from light to dark, determines how sharp or how subtle the resulting curve appears to advance or recede, creating the illusion of a three-dimensional form. The line may or may not be absorbed by the value.

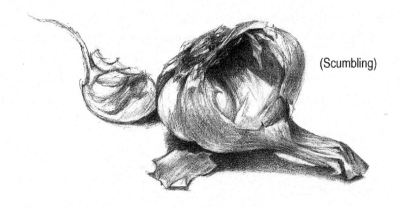

(Scumbling)

Line,Shape, and Value in Transition

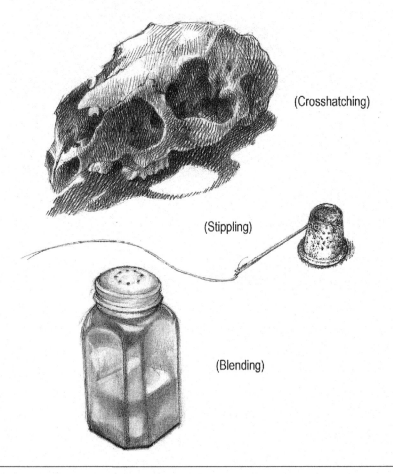

(Crosshatching)

(Stippling)

(Blending)

Marking Gesture

How the marks, which make up a marking system, are made also has an effect on the overall drawing. Marking gesture is the physical act of putting marks on the drawing surface. A mark may be made in unlimited variations. It can be drawn dark, light, thick, thin, controlled, aggressive, soft, rough, and on and on. Each variation will lend to the drawing its flavor. This influence can be major or minor. In one drawing the mark may be quiet and functional, simply a tool for the marking system. In another drawing the mark making process may share an equal role with the subject matter as one of the main issues. Or the mark could be what the drawing is about.

Each marking system has a specific gesture that is part of its character. In the beginning you will want to develop your gesture around that definition.

As in penmanship, there is a personality in the marking gesture and no matter how the mark is made it will, to some extent, always reflect the drawer's individuality and make the drawing uniquely the drawer's.

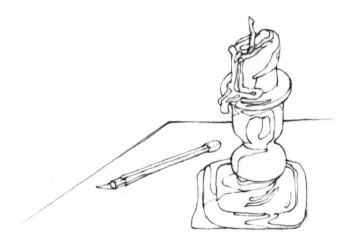

Composition

Every drawing is drawn on something and every mark made on that drawing surface must be placed somewhere. Composition is the

way the marks are arranged on the drawing surface. A drawing surface can be practically anything that will hold a mark but the principals that need to be understood at the beginning are best studied first on a sheet of drawing paper. The area that contains the drawing, edge to edge, is referred to as the picture plane.

A drawing's composition is defined by how every mark made on the picture plane relates to every other mark and the space that surrounds them. On the most basic level composition is the relationship between the positive shapes (things that are drawn) and negative shapes (the space not drawn). In a drawing that is an illusion of space, the subject matter is referred to as the figure and surfaces that hold and surround it are considered the ground.

Note:

Figure in figure/ground relationship refers to any type of subject matter. It is not a reference to only the human figure.

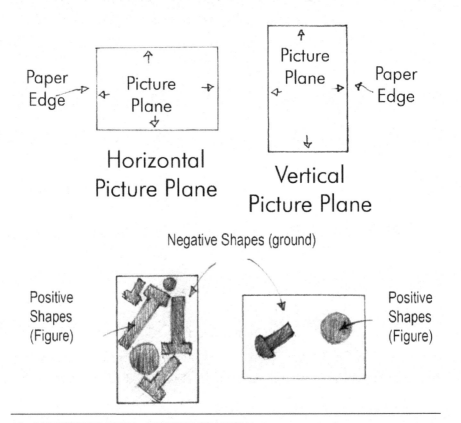

The figure elements of the drawing are treated as positive shapes and the ground elements are treated as the negative shapes.

Note:

Even though it is much smaller than a drawn object, the smallest mark is still a positive shape as it also occupies a place and space on the picture plane.

In a drawing the way the positive shapes and the negative shapes interact plays an important role in creating visual balance, interest and meaning.

Visual Balance and Interest

A sentence that ends before its thought is finished, leaves the listener "off balance" in anticipation, and the statement seems incomplete. The same thing happens visually when an image does not achieve a visual balance. Visual balance is a basic part of the structure of a visual language. It means that when we look at the image we are not distracted by the way it is put together. The image is solid, it does not "feel" like it is tilting left or right, nor does it seem bottom or top heavy. Visual balance is achieved in the drawing by the way the positive and negative shapes are arranged with respect to the factors that influence visual weight: size, quantity, complexity, edge, direction, and intensity. (Reference Tab #3 page 177)

A drawing needs to have a balanced composition but the composition also needs to be interesting. The Greek philosopher Plato is said to have defined the problem of a good composition as one of finding the **"unity in variety"** and the **"variety in unity."** Or stated in another way, find a composition that is **balanced** and **interesting**. A balanced composition that has unity and variety promotes interest.

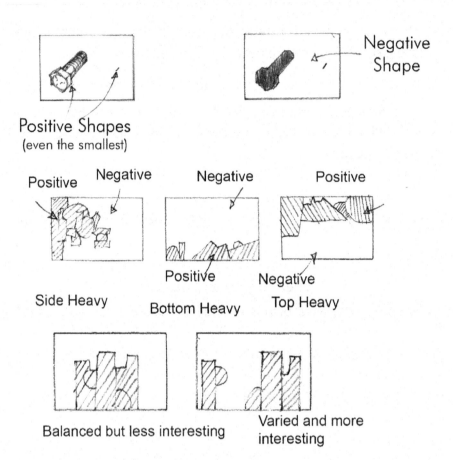

Positive Shapes
(even the smallest)

Positive Negative Negative Positive

Positive Negative

Side Heavy Bottom Heavy Top Heavy

Balanced but less interesting Varied and more interesting

Composition and meaning

The way the positive and negative shapes are organized (structured) has an overall influence on the meaning of the drawing. That structure can be tight and tense, loose and mellow, neutral, or an infinite number of like possibilities. Each arrangement imparts its own "feel" to the drawing. It is the drawer's objective to arrange the positive and negative space in a manner that supports the "feel' of the idea being developed. With composition meaning is being created by context, by the placement of subject matter and its relationship to other subject matter and to the picture plane. It is like placing characters on stage. If one draws a paring knife small and near the top of the picture and an apple larger and near the bottom of the picture plane with plenty of space around each, a possibility is implied. Each object has an explicit function in the real world

and that function suggests a potential activity. Because the composition is loose and mellow any potential activity does not seem imminent.

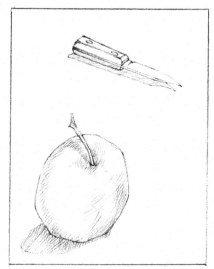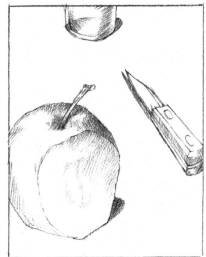

If the composition is changed, by placing the paring knife near the apple that is now partially sliced, the image is no longer a possibility, it is an implied action. It is also now more than that because the interaction and placement of the subject matter brings the viewer "on stage" as an active part of the image's content.

Media and Tools

Media refers to the substances that the marks are made of and the tools are the instruments used in the application. In a graphite pencil the graphite is the medium and the pencil is the tool being used. Drawing media can be solid, powdered, or wet, and most can be used in all three forms. All media have visual characteristics that affect the way a drawing looks and consequently how it reads. These characteristics are determined by the specific medium, its form, the marking system, marking gesture, and the tool used in application. Media can vary in appearance from being soft and transparent to crisp and opaque and have an unlimited number of variations in-between. Each variation imparts its "feel" to the drawing.

The choice of medium and the tool used is determined by finding the one that has characteristics that function with the marking system, support the idea being developed, and are practical for that type and size of drawing.

Format

Format refers to the drawing's physical appearance i.e. its size, shape, and the makeup of the surface to be drawn upon. It is important to remember that variations in size, shape, and surface are distinct possibilities and that they do play an important role in the read of the drawing. In the beginning, the role is one of providing a neutral environment for the image. This is accomplished through the use of a standard sized sheet of drawing paper. The commonality of a standard sheet of drawing paper makes it almost "transparent" to the viewer. It is neutral, neither adding to nor subtracting from the drawing. This neutrality is important in the beginning as it will allow the focus to be on more pressing issues. Later, format will be given a more active role.

The Finished Drawing

The drawing is finished when the idea has been developed to the point where we have made all aspects of the drawing as good as we can for who we are at that moment and within the given time constraints. The drawing is complete and it is time to move on.

The next stage is to see what we can learn from the finished drawing. At some point in the drawing process, through the visual conversation, the drawing grew beyond the original idea into its own entity.

Note:

Each idea has its own life. Some ideas grow into drawings that are radically different from the original idea and some grow less, remaining closer to the original idea. That is fine, and to be expected, as long as we have been open to the possibilities presented in the drawing process.

The drawing has developed its own content and meaning and it is our responsibility to try to understand what it has become. What are the drawing's formal and narrative strengths and weaknesses? What is our understanding of the drawing's meaning, what is it saying about us, and to what extent does that seem true to who we are and what we were trying to accomplish? We want to look at the drawing as objectively as possible and try to understand what makes it interesting, intriguing, and beautiful, or not. How well have we executed our craft? Where did the idea end up and does it present related ideas to be pursued in other drawings? Where did the drawing surprise us and why? What has been learned?

Learning how to draw, drawing's craft, is always the prevailing problem for the beginner. This means that a careful study and understanding of the strengths and weaknesses of the image, with respect to skill issues involved, is the first order of learning. In this book these drawing issues will be made clear and specific to each assignment.

The learning can be as factual as the perceptual understandings that come from the close observation that is required to draw accurately. When drawing with accuracy we are "really" seeing what is being drawn. We are learning to see the difference between what we think we know and what we actually see.

When we think of a pencil, what we think we know is that it is a long, narrow, equal width object, that when sharpened, has a pointed end. It is actually seldom seen like that. Drawing the pencil accurately, as it would normally be laying on a surface in our everyday encounters, it becomes readily apparent that what we know is not what we are seeing. One end or another will most likely appear larger than the other and it may or may not seem pointed depending on how we are looking at it. We are learning some specific things about that particular pencil and pencils in general. Even the most mundane object has its "life." This particular pencil has had, or will have, a purpose and the wear, or lack of, gives it a history and a presence that references time, use, and the user. We have increased our appreciation for, and understanding of, what it is, its make up, and the way it relates to a whole. It is meaningful

and by accurately drawing it we become acquainted with and make an expression of that meaning. The drawing has become our one- to- one experience with a part of our world and one way of better understanding it. A small part, yes, but a part nonetheless, and there was no intermediary, no one was interpreting or translating it for us.

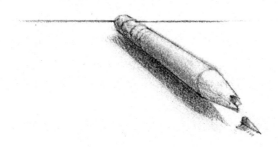

Or what we are learning from our drawing may be more intellectual, as abstract, complex, and personal as seeing in the image a new awareness of some aspect of ourselves and or our lives. The drawing becomes a metaphor, a mirror, a way of seeing into and gaining understanding about ourselves. A large part of who we are is the accumulation of our choices past and present. Recognizing our choices and trying to understand them is an important part of knowing ourselves. The drawing is a collection of choices: the idea to be developed, what to draw, how it would be arranged, and where to follow the drawing as it develops the idea into an image that is a new expression of ourselves. All images have meaning and, like a mirror, reflect aspects of who we are by the way we interpret them. This is possible with any image but it is most enlightening when the image is of our own fashioning. The image is a personal one-on-one. It is about us, our ideas, and yet it has gone beyond us, has grown, and understanding what it has become, can tell us or ask us, a lot about who we are at this moment.

We are learning to develop our ideas and to express them publicly. We are learning to believe that our ideas are valid and an important part of the fabric of our society. We are saying visually "This is what I think, I made it, I am responsible for it, and I am growing from it."

In drawing we are learning to think visually. We are learning literally

and conceptually to see and think about things in a different way. When we learn to think with tools that are new to us we are expanding our whole process of thought. We are gaining another tool to use in our search for understanding and purpose.

In the process of drawing we are learning, or relearning, the basic joy of making something as good as we can. A joy that comes from knowing that we have exceeded ourselves in effort and accomplishment. We have made something that did not exist before, something that is, to some extent, all itself, provocative and unknowable, yet a part of us. The specifics of what is learned belong to each of us and are as limitless as is our desire to understand.

The Public Critique

In order for us to take our final step in learning the drawing needs to go public. The drawing needs to be seen through the fresh eyes of an observer other than ourselves. Although there may have been in-progress viewers, we have, for the most part, been giving the drawing a personal critique all the way through and it is now time to see what others think about its strengths and weaknesses. An objective eye can be a very important ally in our learning. We must be ready for a variety of responses. There will be positive and critical feedback and there will be silence. In most instances it will be some combination of all of these, depending on who constitutes the audience. It is our responsibility to listen to all that is being said, evaluate it, and absorb what is of value, think about what we do not understand, and dismiss the meaningless.

Equally important to the qualitative critique is the audience's personal response to the drawing. What does it mean to them? An image is like a mirror and it is the nature of mirrors to reflect each of us differently. The drawing's integrity, the quality of our effort, is like a polish and the more there is of it, the more reflective the drawing becomes. It is the irony of effort. The better we make the drawing the more it becomes about itself, and less about us. It is becoming a better mirror. We looked at the drawing to see what we saw in it when we finished and it is time to hear what others see in it. This is a very important part of the

learning. Often the drawing is saying things that we completely miss because of who we are and the fact we are so tied to it. What the viewer is saying is not right or wrong. It is their reflection and we want to hear what they see. We do not have to agree but as long as the viewer is serious, we do need to listen. The viewer is helping us to see the drawing in its greater potential.

2

Line, Shape, and the Self

Chapter #2
Drawing Assignment #1

This is a drawing exercise that uses **Line** to accurately define **Shape**.

Skill Development:

In this exercise you will be using an **Objective Line** to accurately describe a group of specific **Shapes**. (Reference Tab #1 page 162) Doing so is the first step in developing the **Hand Eye Coordination** required to draw accurately.

Objective Line

The Objective Line is a line that has a consistent width and value. It is a no-nonsense line that is exceptional for developing hand-eye coordination. The Objective line is our first step into the dance that is line quality. It is a physical response orchestrated by close observation

Hand Eye Coordination

Hand eye coordination is the coordination that is developed between what we see with our eyes and the way our hands respond. Like all forms of physical coordination it is a physical adaptation and as such it can be learned with practice.

Note:

Accurate and controlled description is the first step in learning to draw.

Procedure:

- On a small sheet from a sketchbook draw the shapes printed below with an objective line.
- Fill half the picture plane with a repetition of the given shapes.
- Fill the remaining half of your picture plane with the repetition of shapes drawn from a few objects of your choice. Draw accurately the outline of their shape as observed.

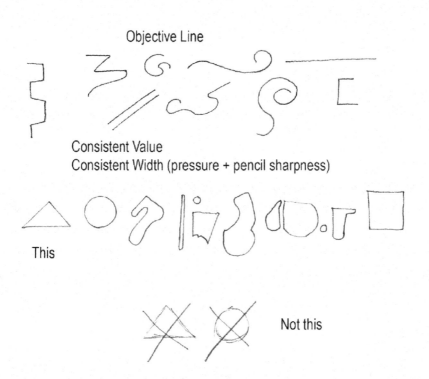

Objective Line

Consistent Value
Consistent Width (pressure + pencil sharpness)

This

Not this

Line Quality

When you see that your drawn shape is not accurate or that the line quality has slipped, erase and begin again, be rigorous, but not obsessive. An Objective Line is drawn with a steady even pressure, moving the pencil slowly and accurately. In order to keep a consistent width one has to maintain a sharp point on the pencil. Do not sketch the lines. An objective line is a singular line.

Materials: (Chapter 8 page 145)

Note:

The material for each lesson are specific to that lesson. It is important that you have the right materials for each lesson. The Materials Chapter will give you the information that you will need to make the right choices for your drawing. Check it to understand the materials needed for each lesson.

- Choose a pencil that will give you a crisp clean line of medium darkness. B HB
- A kneaded eraser
- A vinyl eraser
- A sketchbook (bonded paper approx. 9"x 12" or a half sheet of 18"x 24")

Note:

Most of the drawing assignments can be drawn on a bonded paper sketch pad. You can use two, one small (approx. 9"x 12") and one large (approx. 18"x 24") or you can use the large size and cut it to size for smaller drawings. In the later assignments you will be asked to use a Rag paper if it is available.

The Critique:
Skill Development:

How accurately have you reproduced the given and your chosen shapes? How is your Objective Line quality? Does it have a consistent width and value?

Note:

A critique is always a review of how well one has or has not met or surpassed the objectives of the drawing.

Chapter #2
Drawing Assignment #2

This is an **Objective Line** drawing that uses **Shape** to define the **Major** and **Minor Contours** of your object. It has a **Closed Composition** that develops its **Visual Interest** and **Balance** through the **Visual Weight** factors of **Size** and **Edge.** Your idea will come from the **Realistic** category, it will consider the concept of the **Everyday Object** and how that object represents one of the small unassuming choices that you have made as a part of the definition you give to your life. This is a small (approx. 9"x 12") drawing.

Skill Development:

In this drawing you will be using the Objective Line that you worked with in Assignment #1, to accurately describe the shapes that define the **Major and Minor Contours** of the object that you are drawing.

Major and Minor Contours

Major contour is the basic outline of the object being drawn. Minor contour is the shape of the light, shadow and pattern that make the object visible.

Marking System

Using an Objective Line to describe the Shapes that define the major and minor contours is the first marking system. In it **Line and Shape are used to create a three-dimensional illusion.**

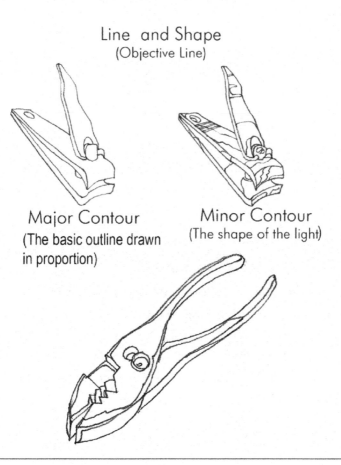

Line and Shape
(Objective Line)

Major Contour
(The basic outline drawn in proportion)

Minor Contour
(The shape of the light)

With this marking system <u>there is no shading</u>, <u>no sketching</u>, and <u>no single lines.</u> All lines must connect to become shapes, even if they are very thin shapes, otherwise the marking system loses its consistency and the image goes "flat." Because consistency is a key to any language, all your drawing should be done free hand (no rulers) otherwise every line would require the same degree of perfection and that is not possible nor desirable.

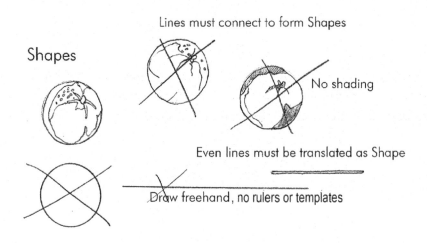

One must draw slowly with a great deal of attention to line quality and accuracy. If the shape you are drawing is not accurate erase it and draw again. Erase, but be reasonable, accuracy will grow with time and patience.

Note:

Failing is not failure. Failure only occurs when one quits trying. You will be doing a lot of erasing, everyone does.

One of the major objectives of this book is to teach one to draw accurately what they see. To do so one must see things as if for the first time and with the curiosity of a child.

Note:

Draw what you actually see and not what you <u>think</u> you know.

There are several visual methods to help one understand what is being seen. (Reference Tab #2 page 170) Understanding how to use these aids is crucial to drawing accurately. It is important that you spend some time learning them.

In this drawing the object does not have to be drawn its actual size but it does have to be visually in proportion to itself.

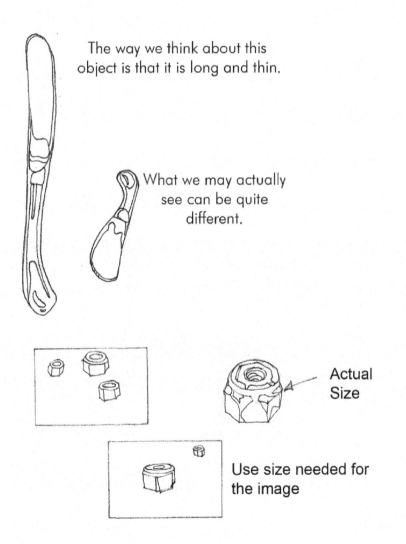

The way we think about this
object is that it is long and thin.

What we may actually
see can be quite
different.

Actual
Size

Use size needed for
the image

Concept:

Note:

The concept is a general definition from which you will generate an idea to develop in the assignment. The specific idea is determined by you.

This drawing is based on a **Realistic** idea that considers the personal concept of the **Everyday Object** while taking into account your visual **Point of View.**

Realistic

In this book realistic defines two aspects of drawing. It is a category of ideas that refer to life, your life, and the way you are experiencing it, your activities mental and physical. And it refers to the use of a visual vocabulary to describe subject matter in a manner that References the physical phenomena of sight, i.e.drawing what you see, drawing realistically.

Note:

In order to understand and develop the craft of drawing you will be asked by the assignments in this book to draw accurately what you see, to draw realistically and to draw from the fact.

Drawing from the fact

In the assignments you will be asked to draw from subject matter that can be drawn from the fact. That means drawing from the actual subject matter as opposed to some Reference, like a photograph, of it. In that way there is no one else describing your world for you and drawing from the fact is the best way to learn the craft of drawing. It is description based on visual perception and perception is the starting point for the visual development of thoughts and ideas.

The Everyday Object

This drawing is about those everyday things that in some small way define you. They are items that reflect choices you have made and they are often functional but a forgotten part of your life. To carefully describe them and to place them in a balanced and interesting composition is to celebrate them and to make you a little more aware of yourself.

Point of View

How you look at what you are going to draw is your point of view and it has considerable influence on how it is "read." Point of view is literally the position you take when you look at something. In drawing it refers to the point from which you draw your subject matter and, consequently, it also establishes the viewer's point of observation.

Point of View
(The way we look at things)

If you look at your subject matter in a way that is recognizable, the common way it is seen, then it reads basically as what it is. If you draw it while looking at it in an unconventional manner then it reads with a wider range of possibilities, ranging from factual to obscure. One way is not better than another. What matters is how you want it to read. In

the drawings of this lesson you will want to use the common way your object is seen because you want it to read as itself.

Note:

In order to draw accurately one must maintain a consistent point of view. In order to do so one must place the subject matter and one-self in a position that makes this possible. A viewing device is often desirable. (Reference Tab #2 page 170)

Composition:

This is a **Closed Composition** drawing that develops **Visual Balance** and **Visual Interest** (**Positive** and **Negative Shape** relationship) through the **Visual Weight** factors of **Size** and **Edge.** (Reference Tab #3 page 177)

Closed Composition

A Closed Composition is one where the whole of all the things being drawn are contained within the picture plane. That means, that none of the objects being drawn are "cut off" by the edge of the paper, nor do they "touch" the edge, everything drawn is contained. Objects can come very close to the edge but there is always a negative space between the object and the edge. A Closed Composition forces one to make very deliberate decisions about where, on the picture plane, to draw the subject matter and how it relates to the edge.

Closed Composition

This

This

This

Not this
(later)

A Closed Composition also has an effect on the content of a draw-ing. In a Closed Composition all of the subject matter rests within the edge of the picture plane, making the edge act as a visual restraint that contains the subject matter and bars the viewer. A Closed Composition acts like the cases in a jewelry store, where we can look but not enter, making the viewer, just that, a viewer and not a participant. It imparts an "intellectualism," "consider this," or a preciousness to the drawing.

Visual Balance and Visual Interest

As this is your first image, you are going to let composition consid-erations rest on your intuitive sense of visual balance. You are a mem-ber of the most image oriented society that, we know, has been on this planet and your sense of visual balance has been sharpened by the multitude of images that you see daily. Each one of those images has had a trained eye working to make them appealing, and consequently, if unconsciously, you have developed a strong sense of visual interest and balance.

The same considerations that make a meal interesting and balanced are similar to those that make a composition interesting and balanced.

The interest in both is based on variety and the balance is based on their unity. In a composition variety means that the relationship between the positive and negative shapes vary in size and spacing. Unity means that the composition is organized so that it "looks" and "feels" balanced, it does not look like it is heavier on one side or the other or at the top or bottom. You want to draw your object (the Positive Shape) on the picture plane (the Negative Shape) in a placement that gives your composition interest and balance.

Positive and Negative Shape

In a drawing the third dimension (Form/Space) is an illusion that is created on a two dimensional surface with two-dimensional shapes. The shapes that contain what is drawn are the Positive Shapes and the shapes where nothing is drawn are the Negative Shapes. The blank sheet of paper, the picture plane, is the initial Negative Shape. The shape of anything drawn on it is a Positive Shape and breaks up the initial Negative Shape. The way the Positive Shapes break up the Picture Plane and create Negative Shapes defines the Positive/Negative Relationship. The drawing's compositional balance is a consideration of how the visual weight of the Positive Shapes relate to the visual weight of the Negative Shapes.

There are six factors that affect the visual weight of the Positive and Negative Shapes: Size, Quantity, Complexity, Edge, Direction, and Intensity. (Reference Tab #3 page 177)

Size and Edge

In this drawing you will want to use the Size and Edge as the visual weight factors used to create interest and balance in your composition. (Reference Tab #3 page 177)

Positive Shape (what is drawn)

Negative Shape
(what is not drawn)

Interesting and Balanced Compositions

Object creates Visual Weight
by distance from Edge and the
Harmony of their parallel
Edges

Use of Size and Edge as devices for creating
Visual Weight to develop Compositional

Balance

Objects create Visual Weight through
distance from Edge and the way they
contrast with the Edge

Thumbnail Sketches:

A thumbnail sketch is a quick "what if" drawing drawn on a very small scale. They are meant to help you work through a series of ideas, and possible compositions, in a short period of time in order to give you a starting point.

It is important that the shape of your thumbnail sketch's picture plane is the same proportion as the picture plane that you will do your drawing on. It serves you no compositional purpose to compose a square picture plane if you want to draw on a rectangle.

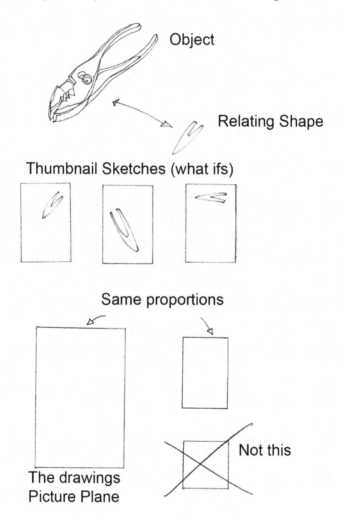

Object

Relating Shape

Thumbnail Sketches (what ifs)

Same proportions

The drawings
Picture Plane

Not this

The thumbnail sketches illustrated here will give you an example of their size and the way they are simply "suggestions" of possible compositions and not tiny detailed drawings. Initially the thumbnail sketches are made to consider the whole sheet of drawing paper as the picture plane. You will want to do the same. Initially you want to learn to compose using the whole sheet of paper as the picture plane. That way there

is no visual confusion about where the picture plane begins or ends, it is the edge of the paper, and everything that goes on the paper must be given compositional consideration. No borders for now.

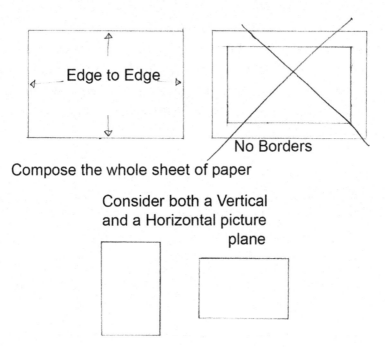

Edge to Edge

No Borders

Compose the whole sheet of paper

Consider both a Vertical and a Horizontal picture plane

After you have chosen your object, do a series of thumbnail sketches using a shape that relates to your object in a general way. Arrange this shape on your thumbnail picture planes in a variety of positions until you find one you feel is interesting and balanced.

Note:

Remember that this is a drawing where the object "floats" on the paper in a position of your choice.

Draw fifteen or more thumbnail sketches considering both horizontal and vertical picture planes. The size that you draw the object is optional so consider how its size works with the picture plane to form a desirable composition.

Idea possibilities:

"From my pocket," "on the top shelf," "in the glove compartment," "over there," "folded in here," "the everything drawer"

Note:

With every assignment there will be a few suggested idea possibilities, these are <u>not</u> directions, they are simply some possibilities that you may or may not use. They are given as starters, ideas for you to consider as a starting point for your own interpretation of the concept. Remember this is about you.

Procedure:

- Chose an everyday object to draw.
- Place your object on your desk or stand, one at a time, so that you can maintain the point of view that you desire.

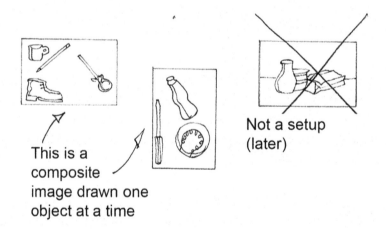

This is a composite image drawn one object at a time

Not a setup (later)

Review Compositional Considerations for visual weight that relate to size and edge. (Reference Tab #3 page 177)

- Draw your thumbnail sketches to determine composition possibilities using the general shape of your object.
- Chose the thumbnail sketch that is for you the most interesting and balanced.

- Using small, general transfer marks transfer the size and placement information to your drawing paper. Do this in a general way with a few short light marks that give you a feeling for the placement and the size. Do not sketch or trace out the image. You are then ready to draw the object using the transfer marks as a Reference.

Thumbnail Sketch

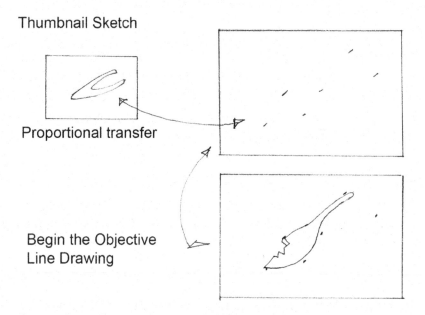

Proportional transfer

Begin the Objective
Line Drawing

- Carefully consider the devices for seeing proportion (Reference Tab #2 page 170)
- Using an Objective line, draw the major and minor contour shapes of your object.

Materials (Chapter 8 page 145)

- Choose a pencil that will give you a crisp clean line of medium darkness.
- 4H-2H-B- HB
- Kneaded eraser
- Vinyl eraser
- A small sheet of paper from your bonded Sketchbook

The Critique:
Skill Development:

How is the quality of your Objective Line? Are the value and width of your lines consistent? How well does your marking system read? Do the shapes you have drawn convey the illusion of your object or are they more of a caricature? Have you drawn the proportions of your object accurately?

Composition:

What do you think makes this composition interesting for the viewer? Does the composition feel visually balanced and of one piece? How does your composition interact with the picture plane to reinforce the content/meaning of your image?

Content:

What was the strongest/weakest aspect of your choice of an object? To what extent, if any, does your choice of an object and its placement "say" anything about you?

Note:

The content of a drawing is what the finished drawing has become about. It is what the drawing is "saying," its meaning.

Always Considered:

What would you do differently? Does any aspect of the drawing "go beyond" your expectations? What are they?

Chapter #2
Drawing Assignment #3

This is a drawing that is a **collection of symbolic objects** that are drawn and arranged on a two-dimensional plane using a **Line** and **Shape Marking System**. It has a **Closed Composition** that develops **Visual Interest** and **Balance** through the **Visual Weight** factors of

Quantity, Size and **Edge.** Your idea takes into account the **Implicit** and **Explicit Content** of the subject matter. The idea will come from the **Realistic** category and explore the concept of the **Self Symbol** through the use of **Symbolic Realism**. This is a large drawing (approx. 18″x 24″).

Note:

Throughout the book each assignment is a continuation of the objectives that were presented in the assignments that precede it. Before you start your drawing, reconsider those drawings: what went right, what went wrong and what do you want to improve on in your current drawing. If you are unsure of any of the drawing considerations that have been covered go back and review them.

Skill Development:

As in Assignment #2, in this drawing you will use Objective Line to create the Major and Minor Contours of your objects and the Line and Shape Marking System. Specific attention will be given to the quality of your Objective Line (a consistent width and a consistent value) and the accuracy of your shapes.

Concept:

This is a drawing based on **Symbolic Realism**. It uses the **Explicit** and **Implicit Content** of the subject matter in a drawing that is a **collection of symbolic objects** arranged in a manner that explores the concept of the **Self-Symbol.**

Symbolic Realism

Symbolic Realism defines one way of creating and interpreting content in an image. In symbolic realism the subject matter is drawn realistically and is a symbol for itself. Content is developed by what one selects for subject matter with respect to its **Explicit** and its **Implicit Content.**

Explicit/Implicit Content

All things have an explicit and an implicit content. It is what they are and what that represents. A baseball glove is a glove worn to catch baseballs (explicit) and it represents the multiple activities of baseball (implicit). Accurately describing an object in a drawing makes clear its explicit and suggests its implicit content.

The Self Symbol

The concept of this drawing is one of self-identity. Who are you? Considering the possibilities for explicit/implicit content select a group of objects that in some way tell your viewer something about yourself. Make your selection carefully, choosing objects whose explicit/implicit contents work together to reinforce your idea.

If you wish to use more than one identity make sure that your choice of objects clearly delineates one notion of "self" from another. You may also want to explore the notions that we often define ourselves by what we are not.

Composition:

This drawing is a **collection of symbolic objects** that are arranged in a Closed Composition. The Visual Balance and Visual Interest are established by using **Quantity,** Size and Edge as the factors for Visual Weight (Reference Tab #3 page 177) with consideration given to **Compositional Energy**.

A collection of symbolic objects

In this drawing the self-symbol objects are independently arranged on a two- dimensional plane. Each piece can have its own size and place on the picture plane. This image is one that is <u>devoid of a pictorial space</u>. It is a collection of objects, drawn three-dimensionally, whose meaning must be brought together in the viewers mind by the objects explicit/implicit content and by context.

Line and Shape
(Objective Line)

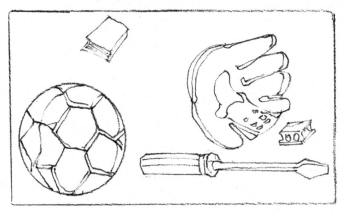

Context

The context of an image's subject matter works like characters on a stage. Context is the way each piece of subject matter relates to every other piece in placement, size, complexity, the intensity with which it is drawn, and its explicit/implicit content. It is the way those relationships suggest possible meaning.

Placement creates the physical Reference between the objects. The placement of one object to another can be tight with a tense or intimate potential or it can be loose with a distance that suggests a lack of or the possibility of interaction. A large object demands more attention, suggesting more importance, than a small one of the same degree of complexity. A complex object requires more attention than a less complex object of the same size.

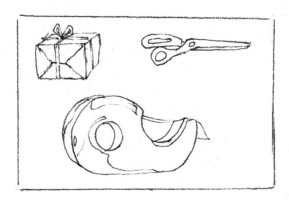

Subject Matter sets up context

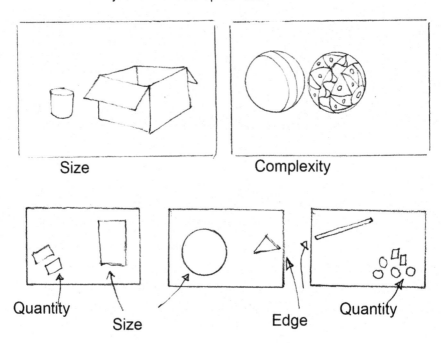

Size

Complexity

Quantity

Size

Edge

Quantity

And, although it is not a part of this drawing assignment, drawing an object with more intensity of value gives it more presence in the drawing than one with all other factors being equal.

Note:

The meaning that develops through context is a potential. It is not a formula.

Quantity

Consider the influences of **Quantity**, Size, and Edge as the visual weight factors that you use to achieve interest and balance in your composition. Quantity is new in your consideration of visual weight. (Reference Tab #3 page 177)

Give attention to the ways that the quantity and size of your objects and their relationship to the edge of your picture plane can be used to support the content of your drawing. Is one object (size or quantity) more symbolically true of you than another? Are there aspects of you that are at your center and others that are more on the edge of yourself? Is one part of you big and balanced by a whole group of small identities? Is there a very stable part, of who you are, that balances the hectic or confused part of you?

Note:

Pay close attention to your negative spaces/shapes (the spaces where there is no drawing). Treating these spaces as filler or simply "background" is a very common error.

Compositional Energy

The way a composition "feels" sets up the compositional energy for your drawing. Establishing that energy is one of the major roles of your compositions. A composition can suggest a visual feeling that is hectic, stable, quiet, or loud, depending on its arrangement. You want the compositional energy to be consistent with the content of your image. If you are speaking to a quiet side of yourself the composition should reflect that and conversely if it is the "wild" side of you then it should reflect that.

Calm

Loud

Point of View

Chose a point of view that maintains the explicit content of your object and one that permits you a comfortable situation for close observation. You are just beginning and there are enough issues to confront without posing an unnecessary obstacle by choosing a difficult point of view.

Thumbnail Sketches

Having chosen a group of objects for your drawing, the next step is an exploration of compositional possibilities through a series of thumbnail sketches. Use the general shapes of your objects so that you can quickly move through a whole series of "what ifs." Do not overdraw them at this point, you want to be able to look at a lot of possibilities.

Remember this is **not** a still life set up where you set up all of your objects and draw them as they relate to each other in that set up. It is a composite drawing where each object is drawn separately in its own placement on the picture plane and in a size that reinforces the drawing's content.

Note:

Since the Size of your object is one aspect of its content they do not need to be in proportion to each other but they do need to be in proportion to themselves.

Maintain Point of View

Possible Idea

Done Quickly

At least a dozen or more

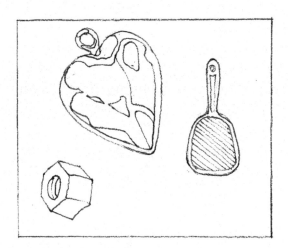

In your thumbnail sketches, as well as the arrangements, consider the possible "reads" of your image.

Note:

"What ifs" mean taking a look at some possibilities that go beyond what you thought you might consider. The thumbnail sketch provides a safe place to start taking some risks, and <u>risk </u>is a necessity for <u>growth</u>.

Idea possibilities:

"I am," "I am this and sometimes," "I have never been," "Mostly I am this but sometimes I am," "There is this me but also this and that"

Procedure:

- Choose the objects that you need for your idea.
- Review Compositional Considerations for visual weight. (Reference Tab #3 page 177)
- Draw your thumbnail sketches.
- Chose a thumbnail sketch.
- Place your thumbnail sketch next to your drawing paper and transfer the basic size and placement information to your drawing using only Reference marks to designate each object's placement.
- Set your objects on your desk or stand, one at a time, so that you can maintain the point of view that you desire.
- Draw your objects **one at time** using the Objective Line to draw the Shapes that define the major and minor contours of your objects.
- Carefully consider the devices for seeing proportion (Reference Tab #2 page 170)

Materials: (Chapter 8 page145)

A pencil that will give you a crisp clean line of medium darkness. 4H-2H- B- HB

Note:

If in your last drawing you had to draw with so much pressure, in order to achieve a medium value, that you left indented furrows in your paper when you erased then try a softer (darker) pencil. If your drawing was dark enough but it smudged very easily, then try a harder (lighter) pencil.

- Kneaded eraser
- Vinyl erase
- Bonded sheet of paper for thumbnail sketches
- A sheet of paper from your bonded pad or a better quality paper (check paper quality Chapter 8 page 155).

Note:

When considering the size of your drawing be realistic about the time it will require. The time required should be long enough to demonstrate commitment and short enough to encourage the learning progression from drawing to drawing. To this end consider large image size to be around 18"x 24," more or less. In the world of images that is not a large size but for the beginning drawer using this marking system and these materials, it is large.

The Critique:

Skill Development:

How has the quality of your Objective Line improved from the last drawing? In what ways? Do you have a better understanding of the marking system?

Composition:

What choices did you make with your composition that make it interesting? Why do you think they would be interesting for the viewer? What, if anything makes it not so interesting? Is it balanced? Is balance achieved in a surprising way or is it predictable? (Reference Tab #3 page 177) Does your composition reinforce the content/meaning

of your image? Does it in fact set up a context for your drawing? What role is the negative space playing? How have you used the edge of your picture plane (edge of your drawing paper), size, and quantity? What chances are you taking? Are they effective?

Content:

Does your image "read" as you hoped? Is it unclear? Is it too obvious? Did your choice of objects set up the parameters for the meaning that you desired? Do you think your objects will read for the viewer or would others have worked better?

Always Considered:

Is your drawing interesting to look at? If yes, why? If no, what could you do differently? Does any aspect of the drawing "go beyond" your expectations? What are they?

3

Subjective Line, Shape, and Story Telling

Chapter #3
Drawing Assignment #1

This is a drawing exercise that introduces value and width variation to line **Gesture** in the development of a **Subjective Line**. This is a small drawing.

Skill Development:

Gesture

While it is true that every mark in some way conveys the uniqueness of the individual that makes it, the Subjective Line begins the conscious

process of developing a gestural line quality that is functional and expressive. Like dance, the Subjective Line requires learning some prescribed steps before it can take on the personality of the practitioner.

Subjective Line

A Subjective Line is a line with a varying width and value. (Reference Tab #1 page 162) It is a line that enunciates with a bold mark and then tapers to a whisper, going dark to light, thick to thin, in a graceful gesture that not only describes but gives a "life" to the image it is creating.

A Subjective Line is a line with width and value changes that operate in a fashion similar to the turn signals on a car. The lines width and value "turn on," get dark and thick, to notify the viewer that something is happening and they should take notice. There are several specific places where the "signals" are appropriate. Initially you will have to make the line variations very consciously. They will, however, eventually become instinctive.

Note:

A Subjective Line is a single line that goes from light to dark, thick to thin, or visa-versa, by <u>pressure </u>and not by multiple strokes. The thickness and darkness of your line will depend on the amount of pressure you use when you draw, the sharpness of the pencil point, and the softness of your pencil lead.

A Subjective Line is darker and wider when it makes the sharp and complex turns that are more difficult for the eye to follow. It is light and thin when it is straight or curving gently in a manner that the eye can easily follow.

A Subjective Line darkens and widens when two or more lines come together at a point. This confluence is a visually complex area and the Subjective Line helps to make it clear. It is saying "this is complex, pay attention."

Subjective Line can also help to place one thing in back of another and to some extent it can demonstrate a "feeling" of weight at a specific point.

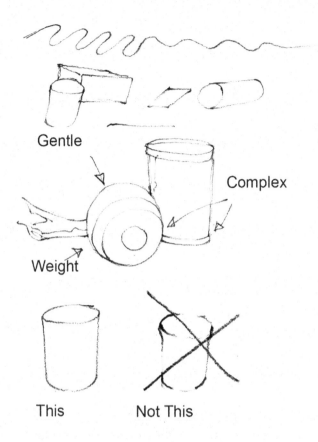

Gentle

Complex

Weight

This Not This

Note:

The change from light to dark, thick to thin is a transition and as such the line will taper from one value and thickness to another. It should be a flowing line that changes smoothly and <u>not</u> a choppy connection of short lines that differ in value and width.

Procedure:

- On a small sheet of paper using a subjective line draw, as demonstrated, the shapes printed below. Then chose a group of your own shapes (keep them simple) and draw their major contours using a subjective line.
- Fill the page with a repetition of these and shapes of your own

choosing while paying close attention to the places where the subjective line changes in width and value.

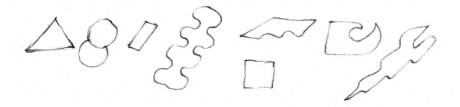

- Draw the given shapes accurately, in a variety of sizes and with a variety of pencils.

Materials: (Chapter 8 page 145)

- Pencil HB- B- 2B
- Kneaded Eraser
- Vinyl Eraser
- A Small Sheet of Drawing Paper

Note:

A Subjective Line requires a pencil that is soft enough to give you a dark/light line variation and hard enough to maintain a fine point. The HB- 2B range should give you that variation. The one for you will depend on the kind of pressure you use when you are drawing.

The Critique:

Skill Development:

Is your Subjective Line fluid throughout? Are your shapes accurate? Is the light, dark, thick, thin, starting to feel natural? Does your line have a taper (a tail) that flows from change to change?

Chapter #3
Drawing Assignment #2

This is a symbolic objects drawing (as in Chapter#3 assignment #3) that uses a **Subjective Line** in a *Line and Shape* marking system. The drawing has an **Open Composition** that is developed by carefully selecting the point of view for each piece of subject matter. Consideration is given to the way Quantity, Size, Edge, **Direction,** and an Open Composition effect the balance and content of the image. It is a **Narrative** drawing that uses **Visual Synergism** to explore a **Word/ Image** idea that references an action.

Skill Development:

In this drawing you will use a Subjective Line to accurately describe the major and minor contours of your subject matter.

Marking System

This drawing uses the same *Line and Shape* marking system that was introduced in Chapter #3, only in this lesson you will use a Subjective Line.

Note:

A Subjective Line as used in a *Line and Shape* marking system has the same variation of light and dark on <u>both </u>the major and minor contour shapes.

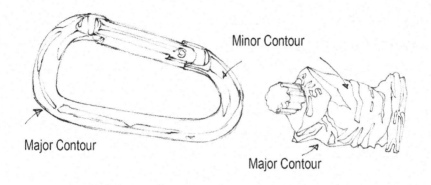

Minor Contour

Major Contour

Major Contour

Concept:

This is a **Narrative** drawing that tells a story through the use of Symbolic Realism and **Visual Synergism**. Consideration is given to the effect that Point of View has on the images content. The story is based on a **Word/Image** association that references an action.

The Narrative (storytelling) Image

All images are both Narrative and Formal statements and determining which statement will have priority in your drawing is one of your first decisions. In this lesson your priority will be the narrative. You will be considering the narrative in its purest form, storytelling. A story is not an illustration. An illustration attempts to leave nothing up to the viewer. A story is a visual suggestion that leaves a varying amount of room for audience interpretation depending on the drawer's desire.

Visual Synergism

Visual synergism is the next step in Symbolic Realism. Visual synergism occurs when the whole becomes more than the sum of its parts. For example; if we draw a pencil sharpener on our picture plane it states its explicit/implicit content as a devise to sharpen pencils, assuming that it is drawn accurately and from a recognizable point of view. If, in the same manner, we add a pencil to the composition, it

states its explicit/implicit content and because of the combination of objects a visual phenomenon occurs. The pencil with the sharpener suggest the activity of the pencil having been sharpened or about to be sharpened, depending on the conditions and placement of each object. There is also the implied possible uses for the pencil after it has been sharpened.

If a third object is added to this image, say a glove, the whole takes on added potential. The glove becomes another reference to the image and the story it is telling. Depending on what kind of glove it is, it can suggest several possibilities through its explicit and implicit content. Is it a child's glove, an adult's, a work glove, or a glove for winter? Each glove would add its own meaning to the story and make it more complex with more information and more possibilities. The way all of the subject matter comes together to suggest possible "reads" is visual synergism.

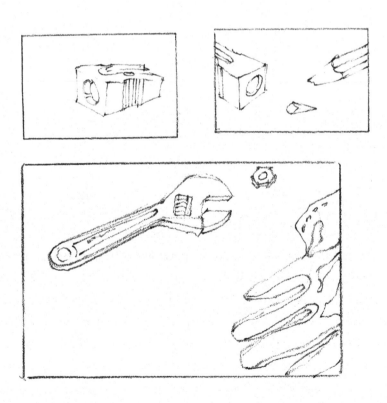

Point of View

Point of view is another part to the drawing's narrative statement. Point of view is a means of directing the way the viewer sees the subject matter. The content of a drawing changes when subject matter is seen from above, below, or from the front or back. Each point of view creates its own group of possible responses. The way we see things says a lot about where we are and what might be happening. There is a normal way that we see most things as adult human beings. If we are standing, we see things one way, if we are sitting we see them in another, lying another. Each of these orientations carry with it the content/meaning that is associated with that activity, depending on the subject matter.

Point of view can also lend the image an insight: a child's, a dog's, or a bird's. It is one of the ways a drawing can help us see our world differently, literally and metaphorically.

Different Points of View

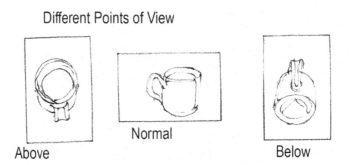

Above Normal Below

Point of view can also make a drawing more interesting. There is a "normal" way we see most things and any time that point of view is altered the result is, to some extent, unexpected and as viewers we are usually interested in, or curious about, the unexpected. However, keep in mind the degree to which the subject matter needs to be recognizable in order to develop the narrative. Point of view can make even the most common object unrecognizable.

Note:

The "unexpected" or "unusual" works when it grows out of your idea. Growth occurs when the surprise is one of insight. This is not to be confused with the novelty of the odd. Odd for odds sake seldom works. It is most often confusing or predictable and of little real interest. <u>Odd is not to be confused with Risk</u>. Risk requires going beyond oneself while maintaining a rigorous critique. Odd denies any critique, yours or anyone's, and is often just a form of evasive posturing.

In this drawing, which is a collection of symbolic objects, each object could be drawn from a different point of view.

Word/Image Association

Keeping in mind the possibilities of visual synergism and point of view, consider the way a word can suggest an action. Chose an action word that interests you. Considering the word that you have chosen select three objects that you feel can be drawn in an arrangement that suggests your action. Remember, this is your story.

Composition:

This is a drawing of a collection of symbolic objects that has an **Open Composition**. Consideration is given to the effects that an Open Composition has on the image's Visual Balance and Content. **Direction** (Reference Tab #3 page 177) is added to Quantity, Size, and Edge as the visual weight factors.

An Open Composition

An **Open Composition** is a composition where some of the positive shapes (the drawn shapes) extend beyond the picture plane. An Open Composition creates an image that suggests that it is a segment of some imaginable whole. When the positive shapes extend beyond the picture plane they exert a great deal of influence on both the Visual Balance and the Content of the image.

Visual Balance

Along with the other considerations for visual weight that are related to Edge (Reference Tab #3 page 177) in an Open Composition, one must pay special attention to the visual weight that is developed at the points where the positive shapes exit the picture plane. This increase in visual weight is due to the "feeling" that the image is fastened at that point by the positive shape as it is cantilevered into the picture plane. The visual weight also increases at this point because the viewer is lead out of the picture plane by the positive shape and "asked" to consider the weight that is implied by the "whole" that is imagined beyond the edge.

Open Composition

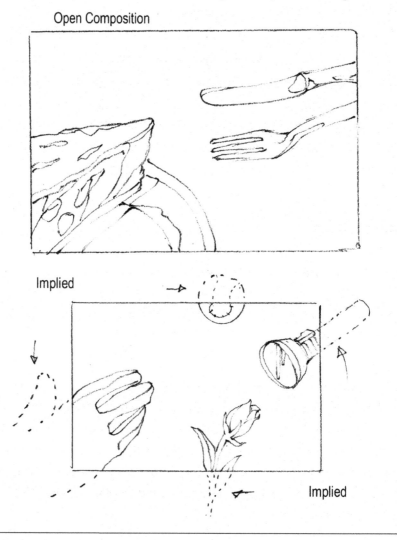

Implied

Implied

Content/Meaning

In an Open Composition the viewer is no longer just an observer, as in a Closed Composition. In an Open Composition they are participating in the creation of the image and its content/meaning by mentally constructing and considering the image beyond the picture plane. This is an important distinction. In a Closed Composition, where all the components are contained, the viewer is asked to consider the image as something apart from themselves, they are on the outside looking in. It is more of a "what is this about" statement. In an Open Composition the image "goes beyond" the picture plane and into the viewer's space, making the viewer a participant. Now the viewer, whether consciously or not, is considering the image as an "I am involved in this" statement.

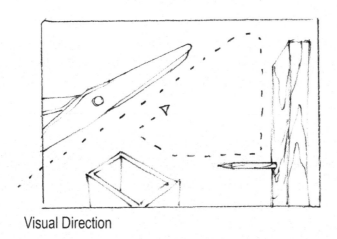

Visual Direction

Direction

Direction establishes visual weight by moving the viewer around the picture plane. The movement is based on the way the subject matter is aligned, its shape, what it is, and its function. (Reference Tab #3 page 177)

Idea possibilities:

"tighten," "loosen," "break," "mend," "lift," "drop," "throw".

Note:

When one first begins to work with ideas there is a tendency to want to make the "big" statement. The statement that deals with the "real" issues, as if, out there somewhere, there were the issues that really mattered. There are issues that really matter, but they are not "out there" they are right here. They are the issues that construct, moment to moment, the fabric of each of our lives, some of the issues are big, most are small, all are important. It is their understanding that we seek. Look here for your ideas.

Procedure:

- Consider the idea possibilities for your drawing.
- Choose the three objects for your idea.
- Consider the point of view you will use for each object.
- Review Compositional Considerations for visual weight (Reference Tab #3 page 177) Size, Quantity, Edge, Direction.
- Draw your (10 - 20) "what if" thumbnail sketches (on a small sheet).

Note:

In this drawing, as in the last, the objects do not have to be in proportion to one another. Make objects the size that relates to its role in the drawing's narrative. The objects do, for accuracy, need to be in visual proportion to themselves.

- Chose the thumbnail sketch that you want to develop.
- Accurately transfer the size and placement information from your thumbnail sketch to your drawing paper (small sheet) using only reference marks to designate the placement of your objects.
- Set your objects on your desk or stand, one at a time, so that you can maintain the point of view that you desire for each one.
- Draw your objects **one at a time** using a Subjective Line with the *Line and Shape* marking system.

- Carefully consider the devices for seeing proportion (Reference Tab #2 page 170).

Materials: (Chapter 8 page 145)

- Pencil HB- B- 2B
- Kneaded Eraser
- Vinyl Eraser
- A small sheet of bonded drawing sheet

The Critique:

Skill Development:

How is the quality of your Subjective Line? Is it becoming more fluid? Does the line quality reinforce your marking system? Is the Illusion of your object readable?

Composition:

Is your composition balanced? How have you used your Open Composition to support your idea? What is happening to your composition when a positive shape goes beyond the picture plane? What aspects of visual weight are you using most extensively? Where is your composition going beyond your initial considerations? What have you decided to do about Point of View? How is it effecting the image? How well is the placement of your objects working in the development of your idea?

Content:

Have you successfully set up a Narrative image that states your "action" idea? Does your image leave any room for the viewer? Is it overstated? Understated? Could you make a better choice of objects?

Note:

It can be most helpful to also ask these questions of a viewer other than yourself. Their input can give you a more objective look at the

work. Remember theirs is an opinion and it is your responsibility to listen to the response, evaluate it, and objectively determine what is valid and what is not.

Always Consider:

What makes your drawing visually interesting? Or not? What is, for you, the most interesting thing about your idea? What do you think makes it interesting for others? If you did the drawing again what would you change to make it as a whole more successful?

Chapter #3
Drawing Assignment #3

This is a Collected Symbols Drawing that uses a Subjective Line in the *Line and Shape* marking system to develop a narrative image based on an action or activity in time. The drawing has an Open Composition that takes into account Visual Synergism and **Visual Movement**. Compositional balance and interest are developed through the visual weight factors of Quantity, Size, Edge and Direction.

This is a large drawing (approx. 18"x 24") that is drawn on a selected sheet of drawing paper. Consider using a good sheet of paper. (Rag or Neutral PH)

Skill Development:

As in Assignment #2, in this drawing you will use a Subjective Line and Shape marking system. Attention is given to the gestural quality of the Subjective Line and to its accuracy with respect to defining the shapes (the major and minor contours) of the subject matter in relation to the chosen point of view.

Concept:

This is a drawing that uses Visual Synergism to develop an idea in the category of Symbolic Realism. The idea is based on an action

or activity that has a time component. The use of Visual Synergism in the Small Drawing assignment was very direct and to the point. When Visual Synergism is used in that manner the content of the image is more controlled by the drawer. In this assignment you want your image to be more provocative, an image that leaves more possibilities open for the viewer.

Note:

In a Narrative image there can be a subtle difference between illustrating, telling too much, being too vague, and not telling enough.

You want an image that gives enough information to set the parameters of the content without dictating it. It is an image that leaves the viewer with several open options for interpretation, as in the earlier example with the apple and the paring knife. It suggests questions like who sliced the apple, why, and what next? It is a drawing that goes beyond the fact.

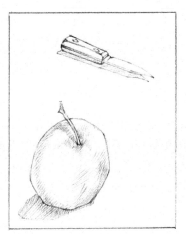 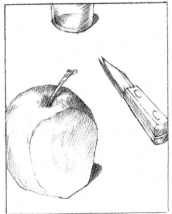

Note:

"Going beyond the fact" means that the content and possible interpretations of the drawing go beyond what is actually there. It has

become an image that, not only leaves the viewer room to interpret, but one that invites them to do so. The image becomes an action or activity in time.

Like the Small Drawing this is a word/image association drawing. The main issue for your consideration will be how to use visual synergism and composition to convey the concept of a specific action or activity in time. Whereas most actions and activities have things that reference them, the time element is intangible and it will have to be suggested by the relationship and arrangement of your subject matter. Another look at the apple and paring knife image will serve as an example. The image's use of visual synergism suggests at least four time components: the time it took to pick up and let down the knife, the time it took to cut the apple, the time between the cutting and leaving, and the time for the return.

When considering ideas that have a time component the choice of subject matter and its state of being can be an important factor. Time has an effect on all things with definitions like: new, old, unused, used, fresh, rotten, here, now, then, in a moment,and later.

Remember that this is your story. What is going on in your life right now, or what has happened recently? Big or little, can you give it a visual presence that creates an image that goes beyond the fact?

Composition:

This is a Collected Symbols Drawing that has an Open Composition. Compositional interest and balance will be developed through the visual weight factors of Size, Quantity, Edge, and Direction. Consideration is given to Visual Synergism, and **Visual Movement** as aspects of the composition that create a variety of time responses in drawing, as well as the narration of your idea.

Visual Movement

Visual movement defines the time (speed) and route the composition establishes to move the viewer around and through the image. Visual movement sets the "pace" of the image and it can have innumerable

visual variations with verbal equivalents like: fast, slow, methodic, hectic, ordered.

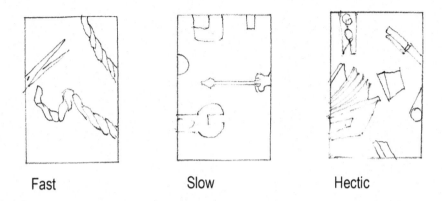

Fast · Slow · Hectic

Because visual movement is developed by the arrangement of the subject matter it is always an aspect of the composition's visual balance and interest. As such, it is for the most part, developed through the factors of visual weight (Reference Tab #3 page 177) with special attention on Direction. There are, however, three other factors that can influence the visual movement and the synergism of the image: **Spacing, Temporal Arrangement** and the **Cultural Read**.

Note:

Spacing, Temporal Arrangement, and the Cultural Read are compositional considerations that can influence the content of an image. They are not formulas.

Spacing

There are two general categories of influence that spacing has on the Visual Movement of a composition: even and uneven spacing. Evenly spaced subject matter sets up a regular movement and an even visual pace. It creates a methodical composition that has a predictable and rhythmic visual movement. It has a stabilizing effect on your composition. An uneven spacing develops irregular movement and a sporadic visual pace. The composition is dynamic in its variety and its movement is more like children on a playground with their unpredictable

starts and stops. It sets up an active composition. One is not better than another, they are different and you want to find the one or the variation that best supports your idea.

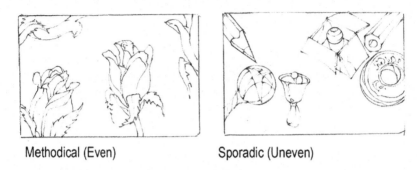

Methodical (Even) Sporadic (Uneven)

Note:

In "supporting your idea" a calm idea <u>generally</u> is most successful with a calm composition and an active idea with an active composition.

Developing the image's synergism through the use of the subject matter's spacing is again related to the way characters are placed on a stage to suggest and support the narrative. Each placement can create a different read. However, there are two basic considerations that, regardless of subject matter, you will want to consider. As the spacing of your subject matter changes, be it closer together, farther apart, or right on top of each other, there is an increase or decrease in the visual interaction that is created in their relationship. By the same means the time reference changes for the action or activity from the possibility that it may happen, will happen, or is happening.

May Happen Will Happen

Temporal Arrangement

Temporal Arrangement defines the way you want your viewer to spend the time they take to consider your drawing. There is the **Poetic** arrangement and the **Prose** arrangement.

Poetic

A Poetic arrangement is an economical composition. It requires the selection of just the "right" amount of visual information, no more, no less. There is a subtle difference between too much and too little. Too much information and the image cannot be taken in as a whole or too little and it loses all influence and becomes simply a Rorschach inkblot test (a reaction vs. an interpretation). An image that is poetically arranged allows the viewer to see the parts of the image as a whole, one entity. It is an image that suggests a story and, while giving parameters, expects that the specific be developed in the viewer's imagination.

Prose

A Prose arrangement is an elaboration. It is a composition that provides more of the visual information, one that directs the viewer through the image at a pace that allows them to consider as they go, while not dictating or illustrating. A Prose arrangement tells more of the story and still leaves room for the viewers own response.

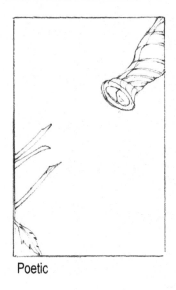 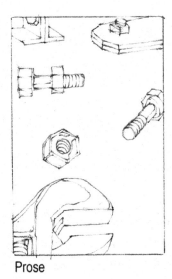

Poetic Prose

Cultural Read

The Cultural Read is a form of visual conditioning. In Western Culture it is our disposition to read an image (it is not as true of an image that has a naturalistic space) from the upper left hand corner to the lower right hand corner. This response is a reflection of the way we read the written word. It is not an absolute. It is a tendency and it can be used, to the image's advantage, by encouraging it, or if it is not desirable, it can be overridden by other compositional factors.

Idea possibilities:

"When it begins," "After this is over," "It started with," "It lasted all."

Procedure:

- Consider your idea and its time component for your drawing.
- Choose the objects (3 - 7) that you think you will use to develop your idea.
- Review the Compositional factors for visual weight (Reference

Tab #3 page 177) and consider your use of visual synergism and visual movement.

- Draw your (10-20) thumbnail sketches. (Small sheet)
- Chose a thumbnail sketch for the drawing.
- Transfer the size and placement information from your thumbnail sketches to your drawing paper using only Reference marks to designate the placement of your objects.
- Set your objects on your desk or stand, one at a time, so that you can maintain the point of view that you desire for each one.
- Draw your objects **one at a time** using a Subjective Line in the *Line and Shape* marking system.
- Carefully consider the devices for seeing proportion. (Reference Tab #2 page 170)

Materials: (Chapter 8 page 145)

- Pencil HB- B- 2B (Or the pencil you have found that gives you the best Subjective Line)
- Kneaded Eraser
- Vinyl Eraser
- Small Sheet of Drawing Paper (**t**humbnail sketches)
- Large Sheet of Drawing Paper (consider using a Rag or Bonded Neutral PH paper)

The Critique:

Skill Development:

How is the quality of your Subjective Line and its accuracy? Can you see a consistent use of the linear variations in your Subjective Line?

Composition:

What aspect of balance was new in this composition? How have you used an Open Composition to create a balance and to support your idea? Point of View? What aspect (Spacing, Temporal Arrangement, Cultural

Read) of composition did you use to develop the Visual Movement in your image? Why did you chose one over the other? To what extent did you use direction as a factor in the visual weight of your drawing?

Content:

Have you successfully set up a Narrative image that states your "action or activity in time" idea? In what ways? How do others read your narrative?

Always Considered:

In purely visual terms, how the final drawing "looks," did anything occur that surprised you? What went right about the drawing as a whole? What could be changed to make it more effective? How did your original idea change in the drawing process? What would you do to the drawing if you could do it again?

4

Line (Sketched), Shape, Value (Scumbling), and the Formal Image

Chapter #4
Drawing Assignment #1

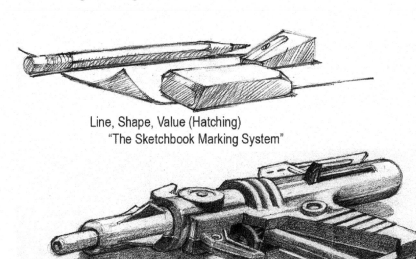

Line, Shape, Value (Hatching)
"The Sketchbook Marking System"

Line, Shape, Value
(Scumbling)

This is a drawing exercise that develops the Subjective line into a more expressive **Sketched Line**. The Sketched Line is a line that searches for accurate definition.

Skill Development:

In this exercise you will be developing a Subjective searching line, a **Sketched Line**

The Sketched Line

A Sketched Line, like a Subjective Line, is a line with variations in width and value. A Sketched Line is a series of lines that begin light, as they search for accuracy, then darkening into one line as the definition is found. It is a line that reveals more of the drawing gesture, one that builds character through the searching process.

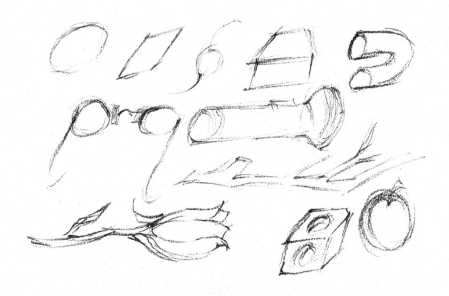

Note:

With a Sketched Line the gesture (the marking making) takes on an added role in the drawing. Like the Subjective Line the Sketched Line has a pure visual energy, but unlike the Subjective Line it reveals more

of the act of drawing, the searching. With a Sketched Line the drawer chooses how much or how little of the drawing (searching) process to let show. In general, the more that the drawing process is revealed, the more the image becomes about the act of drawing. The less the drawing process is revealed the more the image becomes about implicit/explicit content of the subject matter.

The Sketchbook Marking System

The Sketchbook Marking System gives the drawer a system that is fluid, changeable, and one that provides a lot of information quickly. One style or another of it has been the standard in sketchbooks throughout much of history. It is a marking system that is compatible with most forms of rendering (Reference Tab #4 page 180) and is often used during the initial stage of a drawing. It begins with a sketch line that establishes proportions, placement and major contours. This is followed by a linear hatching that quickly gives the drawing a reference for volume and light.

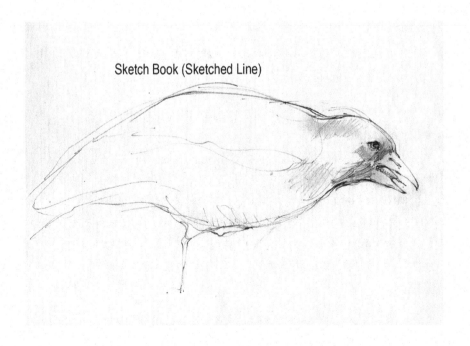

Sketch Book (Sketched Line)

Procedure:

- Draw (small sheet) the group of simple objects using a Sketchbook Marking System.
- Fill the page with four or five objects.
- Let each object demonstrate a sketched line that reveals a different degree of the searching
- Lay the hatching down quickly with attention to basic volume and light.

Materials: (Chapter 8 page 145)

- Pencil 2H-H-HB- B- 2B

Note:

A Sketched Line requires the same qualities in a pencil as did the Subjective Line. Since a searching line is a line that builds from light to dark you may want a slightly harder (lighter) pencil than was used a Subjective Line.

- Kneaded Eraser
- Vinyl Eraser
- A sketch book (bonded paper approx. 9"x 12" or a half sheet of 18"x 24")

The Critique:

Skill Development:

Does your Sketched Line maintain a sense of discipline? Does it reveal a rigorous search for the desired accuracy, or is it just sloppy? Have you retained the fluidity of your line quality or has it become choppy? Is your hatching fluid and does it work to give your objects a basic volume and light?

Chapter #4
Drawing Assignment #2

Descriptive Formalism Drawing uses a Sketched Line and **Scumbling** in a **Line, Shape, and Value, Marking System**. It is an **Arranged Space Still Life** Drawing that begins the considerations involved in developing the illusion of **Three-dimensional Space. Complexity** is added to Quantity, Size, Edge and Direction as the possible visual weight factors used to establish compositional interest and balance.

Skill Development:

In this drawing a Sketched Line and Value are used to describe the shapes of the major and minor contours of the subject matter. It is an image that creates the illusion of **Three-dimensional Space.**

Three-dimensional Space

This assignment begins the introduction to the principles as they relate to the illusion of three-dimensional space: Overlapping, Linear and Atmospheric Perspective, and Picture Plane Placement (Reference Tab #5 page 183). However, in this drawing you are going to draw, with the aid of a view finder, what you see while making note of how these basic principles of spacial perception (the way we see three-dimensional space) play themselves out in the illusion making. If you draw what you see you will accurately draw the illusion of three-dimensional space. Whereas this is true, problems most often arise from the tendency to draw what we think we know, our typical orientation to it, instead of what we actually see. Or when we are not paying attention and allow our point of view to change during the drawing.

Note:

In drawing what is observed, the use of Line to describe Shape is the initial and basic mode of description. First see and draw the major shapes, the positive and negative shapes. These shapes puzzle together to form a whole.

Sketching the major contours

A Formal image is often as much about the Negative Space

In a complex area concentrate on drawing the Negative Space

View Finder

A view finder is a great aid in understanding what is actually being observed. It provides the edges for the picture plane. In order to make the visual transfer from the three-dimensional fact to a two-dimensional illusion, the subject matter and the space around them must first be seen as a series of shapes that are puzzled together to create the whole. There are several techniques that aid in the process of drawing accurately what is observed. (Reference Tab #2 page 170)

Marking System

A Line, Shape, and Value Marking System begins by drawing the object's major and minor contours with a light Sketched Line. The shapes defining the minor contours are then filled, by Scumbling, with a value that corresponds to that of the object. In the scumbling process the line is blended into the value, making the minor contour a shape defined only by value.

Subjective Line and Shape

Sketched Line , Shape, and Value

Note:

A Line, Shape, Value, Marking System is blocky because there is no transition between shapes. That is its nature.

Scumbling

Scumbling is one of the techniques in drawing that is used to create value. Scumbling is the process of making marks on the drawing surface with the drawing media in a manner that develops an even, flat or graded value. In Scumbling the value begins light and builds up to the desired darkness. There are two basic forms of scumbling.

Linear Scumbling

Linear Scumbling uses a series of irregular and random lines drawn one on another in a manner that develops an even value. Initially the individual lines should not be readily apparent, later, when control is acquired, they can be used to suggest the illusion of a texture.

Textural Scumbling

Textural Scumbling uses the texture of the surface that is being drawn on to help achieve its desired value. For this reason Textural Scumbling requires a drawing paper with a surface that has a medium to heavy texture. As the media (pencil, charcoal, conte') makes contact with the surface it collects first on the raised areas (peaks), leaving the depressed areas (valleys) light. This develops an area of light and dark points that the eye visually mixes and perceives as a value. The more the peaks and valleys are "filled" the darker the value appears and to the contrary the less the peaks and valleys are "filled" the lighter the value.

Linear Scumbling

Textural Scumbling

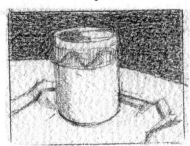

Note:

The means one uses to create value (lightness and darkness) in a drawing depends on four factors: the inherent value of the drawing media (Compressed Charcoal is darker than Graphite, etc.), the value grade of the media (a hard pencil or a soft pencil, etc.), how much physical pressure is applied when drawing, and the marking system being used.

The move from a Line, Shape Marking System to one that includes Value greatly increases the role light plays in the drawing. Now the drawer must also consider, along with the shapes created by light, its corresponding value and range. When drawing from observation, light, as well as making sight possible, is the major influence on the subject matter. Each marking system, in its specific way, creates the illusion by using some combination of the visual elements to interpret the manner in which light illuminates what is being seen. Aesthetically it is one of the main characters in both a Formal and a Narrative drawing. The role that light plays in the image is determined by: the actual lighting situation, the value range one chooses for its interpretation, (Reference Tab #2 page 170) and the way it interacts with the specific subject matter.

Note:

Light and the way it is interpreted is always one of the major defining characteristics of a drawing.

The Lighting Situation

The lighting situation is either natural or artificial. Both have their variables and unique qualities. The choice of lighting situation ultimately depends on the needs of the idea being developed in the drawing. However, there are also practical considerations that are relevant. Artificial light can be manipulated, is constant, and repeatable from day to day. Natural light, while changing from moment to moment, gives one: time of day, season, weather, and nature's visual attributes. Artists who work with natural light either work from memory as the light changes during their observation, return to the image's source at the same time of day and on a day when the conditions are similar, or they work from photographs.

Because of the complexities of working with natural light, artificial light is preferable for the beginning drawer and many of the characteristics of natural light can be intimated with artificial light.

Note:

It requires considerable understanding of illusion making and the phenomenon of visual perception for one to use a photograph as a reference and have the image turn out to be more than a drawing of the photograph. For this reason there is more progress in learning to draw for the beginning drawer to work from the fact.

Light as Subject

Light can be the subject of a drawing. The amount of light and its intensity can set up the mood for a drawing, from dark and mysterious to bright and clear. It can have a direct or indirect focus that gives the subject matter a crisp or soft character. Or the drawer may choose to draw the patterns made by the highlights and shadows.

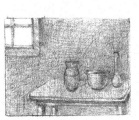

| Dark and Moody | Bright and Crisp | Light as the Subject |

Concept:

This is a **Formal** drawing that is based on **Descriptive Formalism**.

Formalism

In Formalism the drawer is making the image's first concern that of how the image "looks" verses what it "says or a suggested meaning." The focus of a Formal Image is its use of some or all of the Visual Elements (Reference Tab #1 page 162) and their visual energy. It is a drawing that, to the extent possible, is devoid of narrative content. It is a pure visual experience. Formalism can be divided into two distinct categories. There is **Descriptive Formalism**, where the subject matter remains identifiable, and **Abstract Formalism**, where the subject matter no longer has a representational identity. This assignment is concerned with **Descriptive Formalism**.

Descriptive Formalism

In Descriptive Formalism the subject matter is recognizable. The subject matter becomes the "carrier" or the "show case" for the visual elements. In the drawing some aspect of the visual elements that are used to describe the subject matter becomes what the image is about. The subject matter's content remains as neutral, as is possible, while one or more of the elements that give it a visual presence such as line, shape, form, texture, pattern ,or color, becomes the focus of the

drawing. The subject matter's explicit and implicit content is neutralized by carefully choosing what subject matter to draw and how it is composed in the image.

Composition:

This is an **Arranged Still Life** Drawing where the objects that constitute the Still Life are arranged for specific formal considerations. The drawing is based on **Descriptive Formalism** and it is an introduction to the issues involved in composing the illusion of Three-Dimensional Space. **Complexity** is added to Size, Edge, and Direction as the factors to be considered for visual weight.

The Still Life

A Still Life consists of an object or group of objects in a space and in an arrangement that presents Formal/Narrative possibilities for a drawing. As suggested by the title a Still Life is a drawing from life. Up to this point we have been drawing our objects from "life" but unlike "life" we have been drawing them one at a time and making a composite of them on a two-dimensional plane. With the Still Life we will begin our approach to the illusion of three-dimensional "life" space.

When one is creating an image that is an illusion to three-dimensional space the image's composition is always a segment of an implied whole. It is a drawing where the image extends beyond the edges, an Open Composition.

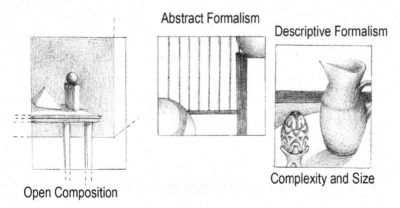

Abstract Formalism

Descriptive Formalism

Open Composition

Complexity and Size

Drawings that involve illusion of three- dimensional space present the drawer with four separate ways of considering composition: an **Arranged Space**, a **Found/Selected Space,** a **Constructed Space**, or a **Composited Space**. An **Arranged Space** is one that is arranged specifically for the drawing. A **Found/Selected Space** is a space that already exists and some portion of it is selected for the drawing. A **Construct Space** is one that is developed in the drawing process, one object at a time. A **Composited Space** is a Constructed Space that is composited from a combination of sources, ranging from the actual object to photographic copies. We will deal with the Constructed and Composited Space in later chapters. In this chapter we will work with an Arranged Space and a Found /Selected Space. We begin in this assignment with an **Arranged Space Still Life**.

Arranged Space

In an Arranged Space still life we choose all aspects of the setup; the place, light, objects and the surface it all rests on. In that way we are able to choose and arrange the subject matter in a way that focuses on our desired formal/narrative qualities.

We have been working with compositional considerations that are based on the relationship between the positive and negative shapes as they interact on a two-dimensional plane. A three-dimensional illusion is still a collection of two-dimensional shapes. As such the visual weight factors (Reference Tab #3 page 177) remain applicable. The slight distinction comes with Direction as a visual weight factor. In a two-dimensional plane image the directional movement needs to be established by the subject matter. While direction is still a weight factor to be considered, an image that alludes to three-dimensional space naturally moves the viewer through the composition, generally from near to far.

However, with the illusion of three-dimensional space there is a change in compositional terminology from Positive/Negative Shape relationship to Figure/ Ground relationship. In a three-dimensional spacial illusion the subject matter is referred to as the Figure and the space that contains and holds the subject matter is referred to as the Ground.

The composition is referred to as the Figure Ground relationship. In Figure/Ground Relationship, Figure refers to all subject matter, the positive shapes, and does not necessarily refer to the human figure.

Note:

When composing a spacial illusion all the visual weight factors (Reference Tab #3 page 177) are applicable. A spacial illusion is still a two-dimensional composition made up of positive and negative shapes. The near and far movement that is developed by the illusion falls into the category of, and works as, another form of Direction.

Complexity

With this assignment **Complexity** will be added to Size, Edge, Quantity, and Direction as the factors to be considered for visual weight. (Reference Tab #3 page 177) Subject matter can be very complex in its characteristics and configuration without suggesting a narrative, or those characteristics can, by becoming the subject of the drawing, overpower the objects narrative potential. For this reason Complexity, as well as being a visual weight factor in the images composition, is a possible consideration for choosing subject matter in a Descriptive Formalism Drawing. Subject matter can be complex by its configuration, point of view, the way other objects relate to it or by the way it is illuminated.

Descriptive Formalism

In Descriptive Formalism the composition is focused solely on visual interest and balance. This is quite different from a narrative image where the composition is arranged in a way that, as well as creating interest and balance, reinforces and helps build the narrative content of the image. In Descriptive Formalism you want the defined subject matter to remain as neutral as possible. You want the composition to simply "present" your subject matter in a manner that is visually interesting, and in a way that makes prominent the visual characteristics that are the focus of your drawing. Review the elements (Reference Tab #1 page 162) and consider the type of subject matter that would allow you

to focus on a particular element. In a drawing like this, which is drawn with a Line, Shape, and Value Marking System, Value and Shape are the defining visual elements. As the defining visual elements, Value and Shape will need to play a major role in the idea you chose to develop.

Line, Shape, and Value

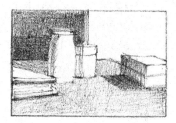

Idea possibilities:

Chose subject matter for one or more of the possible configurations: "for the way they interact," "for the way light creates shapes on their surface," "for the pattern of shapes created by the highlights and shadows made by the direction and intensity of light," "for the subject matter's reflective quality," "for the way the shadows from one object make interesting shapes on another."

Procedure:

- Consider idea possibilities based on Descriptive Formalism.
- Chose the subject matter (1-5) for your idea.
- Thumbnail sketch several possible Still Life arrangements, points of view, and lighting situations using some or all of your subject matter.
- Select your image and set up your light and Still Life.
- Make a view finder that is in proportion to your picture plane.
- (Reference Tab #2 page 170)
- On a sheet of drawing paper (small) establish the drawing's composition by lightly sketching in all of the objects.

Note:

Establishing the composition, and solving issues of placement and proportion, before adding the value keeps the drawing flexible and more open to changes during the drawing process.

- Remember to give yourself proportional and placement marks before beginning the actual drawing.
- From your light line sketched composition, work the value, to the extent possible, from light to dark in the overall drawing using a scumbling technique with the *Line, Shape, and Value* Marking System.

Note:

Building the value up slowly, from light line to its darkest area, gives the drawing room to grow through the drawing process. When a drawing begins lightly, with the whole image being developed uniformly, changes are more easily made and more of the idea's potential is revealed.

Sketched Building Shape and Value slowly

- Keeping in mind the visual element or elements that are the subject of your idea, stop frequently to look at your drawing objectively with an open awareness for their developing quality.

Materials: (Chapter 8 page 145)

- Pencil (Graphite, charcoal, conte')
- Kneaded Eraser
- Vinyl Eraser
- The enclosed drawing sheet

The Critique:

Skill Development:

Have you retained the subjective line quality in your sketched line? Were you able to successfully make the transition from the shapes, that you used in our last marking system, into value? Were you satisfied with the way it read?

Note:

A reminder: A Line, Shape, Value, Marking System is blocky with no transition between shapes.

Composition:

How does your composition focus the drawing on a particular visual element or group of elements? What does the composition do that neutralizes the narrative aspects of your image?

Content:

Is your image interesting because of its visual characteristics or because of the subject matter? How has light been used to make a particular group or singular Element the subject of the drawing? What is the subject of your drawing and is that as you intended?

Always Considered:

Did the drawing take you anywhere that you did not expect? What went right and what did not work as well? Is this an image that interested you? Why? Why not?

Chapter #4
Drawing Assignment #3

This an **Abstract Formalism** Still Life Drawing that is based on a **Found/Selected Space**. The image is developed through the use of a sketched line and scumbling in a *Line, Shape and Value* Marking System. A view finder is used as a device for compositional selection and as an aid in drawing the illusion of three-dimensional space.

Skill Development:

As in Assignment #2, a sketched line is used to develop the image's composition and to accurately define the subject matter. The line work is followed by the development of the linear shapes into value through scumbling.

Concept:

This is an Abstract/Formalism Still Life Drawing that is generated from a found/selected space.

Abstraction

Abstraction is a word whose meaning in the language of Art has changed radically from the past to the present. It was initially used to refer to a representational illusion that was "abstracted" from life, a realistic image. Over time, in Art, the word abstraction has become a definition for images that in some way distort, or that are without reference to, a realistic image.

Formalism

As stated in the Assignment #2, Formalism defines an image that is first and foremost a visual presence. An image where some form of a visual element or elements (Reference Tab #1 page 162) are the subject.

Abstract Formalism

Abstract Formalism defines an abstract image that is based on Formalism. Whereas subject matter in Abstract Formalism is not necessary, this assignment will continue its use. When using subject matter, in Abstract Formalism, its inherent narrative content needs to be minimized or eliminated. In order to do so, and to continue the development of drawing accuracy, the subject matter is abstracted by **selection**. Abstracting by selection means selecting a composition in a manner that makes the subject matter unrecognizable (abstracted). This is accomplished through the use of a view finder and selection is made from either a Still Life set up or a found space. As in Assignment #2 this drawing uses a *Line, Shape, and Value* Marking System.

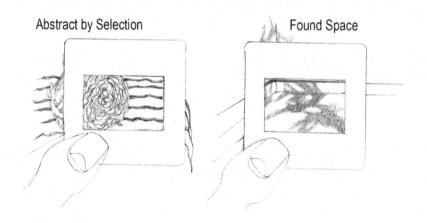

Abstract by Selection Found Space

Pattern

This is an excellent opportunity to consider the use of Pattern as one of the modifying elements in your drawing. (Reference Tab #1 page 162) The Pattern may be one that occurs naturally in a found space or the Still Life may be set up with a particular pattern in mind. The pattern could be: a regular pattern formed by the design of a wall paper, a specific fabric used in the Still Life, or irregular patterns formed by light and shadow as they play upon the subject matter.

Composition:

This assignment is an Abstract Formalism drawing derived from a **Found/Selected Space**. It has an open composition. It is a composition that minimizes or eliminates the narrative content of the subject matter while focusing on the defining formal elements. Size, Quantity, Edge, Direction, and Complexity will be considered as the visual weight factors when selecting a composition.

Found/Selected Space

A Found/Selected Space can be literally that, a found space or it can be a selected portion of a Still Life set up. The benefit of a found space is that it can be very spontaneous, literally found. The task is to select a composition and draw it in such a way that it loses its context. Selecting a composition from a Still Life set up makes it possible to choose both the objects in, and the arrangement of, the Still Life as well as selecting an image from a portion of it. This allows for a more determined and deliberate image, one that focuses on specific formal concerns. In both, a view finder is used to "find" a composition.

Idea possibilities:

"Interesting light patterns on a form, " "complex forms that create interesting negative shapes," "subject matter that can be abstracted into simple forms in contrast with heavily patterned contrasting forms," "harmony of forms, or pattern or lines, or texture," "wallpaper pattern and space"

Procedure:

- Determine the drawing paper to be used and construct a proportional view finder.(Reference Tab #2 page 170)
- Consider the elements, their particular characteristics, (Reference Tab #1 page 162) and with your view finder choose a composition that is abstracted by selection into a visually stimulating image.

- Draw your thumbnail sketches using your view finder. Try a variety of points of view with a Found Space and or a Still Life set up.
- Use views that eliminate recognition of your subject matter and that reinforce an image that is about its formal concerns.
- Transfer image from your thumbnail sketch using placement marks.
- As is Assignment #2 review the issues involved in creating the illusion of three-dimensional space. Using the view finder establish the spacial relationships by drawing accurately the figure/ground shape relationships.
- From your sketched composition work up the value, evenly in the whole drawing, light to the dark using a *Line, Shape and Value* Marking System.

Materials: (Chapter 8 page 145)

- One sheet of drawing paper
- You will want to choose an appropriate paper for the scumbling technique you will be using in this drawing.
- *Graphite, Charcoal, or a Conte' pencil (medium to light) You will want to use a pencil or stick depending on the size of your drawing.
- Appropriate erasers

The Critique:

Skill Development:

Has your sketched line maintained its accuracy and energy? Were you able to work your drawing from light to dark evenly, as a whole? Did your Marking System maintain its integrity of shape and value while creating the illusion of form? Were you able to maintain accuracy without recognition of your subject matter?

Composition:

What would you say is the most interesting aspect of your composition? Does it depend on your use of the visual element or elements that you intended the drawing to be about? If asked what your composition "felt like" what would you say? What factors for visual weight did you use consciously? How does the composition reinforce and become a part of the concept?

Content:

How would you define the "what is it about" of your drawing?
Did your drawing remain abstract?

Always Considered:

Where did the drawing "take" you? What did your drawing show you about the purely visual aspects of drawing? Did your drawing take on a content that went beyond "just" the visual? What, if any?

5

Line, Shape, and Value in Transition (Scumbling, Blending) and a Statement of Personal Preference

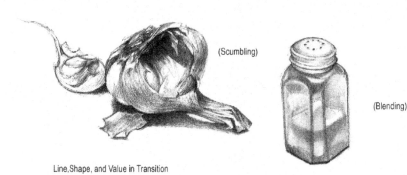

(Scumbling)

(Blending)

Line,Shape, and Value in Transition

Chapter #5
Drawing Assignment #1

This assignment has two components. They are drawing exercises that introduce **value transition** as it relates to **rendering** and the *Line, Shape, and Value in Transition* Marking System.

Skill Development:

Exercise #1

This is a drawing exercise that uses scumbling to develop an even **value transition**, from black to white.

Procedure:

- On as small sheet of drawing paper draw a 6"x 6" square.
- Using linear scumbling build, layer upon layer, an even value transition that goes from black in one corner to white in the opposite corner.
- Create the transition slowly.
- Begin the transition with a light value and develop the darkest value by building value upon value.

Value in Transition (Scumbling)

Materials : (Chapter 8 page 146)

- Graphite pencil (preferable), Charcoal pencil

Exercise #2

This is a drawing exercise that introduces the relationship between form, light, and pattern in the **rendering** of a representational illusion (Reference Tab #4 180) using scumbling in a *Line, Shape, and Value in Transition* Marking System.

Rendering (Reference Tab #4 page 180)

Rendering is the process of creating an illusion, in value (light and dark), that closely relates to visual perception. It is the creation, on a two-dimensional surface, of the illusion of three-dimensional Form and Space and their specific characteristics.

Marking System:

The *Line, Shape and Value in Transition* is the marking system that most completely translates, in value, the illusion of form as perceived through the physical phenomenon of sight.

The *Line, Shape and Value in Transition* Marking System, as its name implies, requires a mark making process that allows the drawer to create transitions in value. There are four basic techniques that are used to build transitions in value; scumbling, blending, stippling, and crosshatching. In this Chapter scumbling and a combination of scumbling and blending are presented, beginning in this assignment with scumbling.

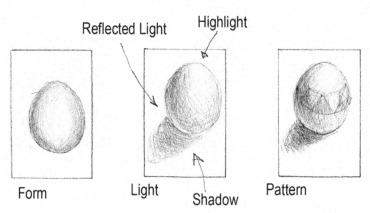

Reflected Light Highlight

Form Light Shadow Pattern

Procedure:

- On as small sheet of drawing paper.
- Chose an egg, a ping pong ball, or a ball that has no pattern and little texture.
- Set your object under a direct light, a single source, (a desk lamp or reading lamp) where there are no competing shadows or highlights.

- Consider the rendering issues of form, light, and pattern (Reference Tab #4 page 180) that are illustrated there.
- Draw your object three times on a small sheet of drawing paper with a light sketched line.
- Use Scumbling in the *Line, Shape and Value in Transition* System for the rendering.
- Render the first object for form only.
- Render the second object for light, while reinforcing the form.
- On the third object invent and draw a decorative pattern on your object. Because pattern falls under the influence of both form and light, it needs to be developed and reinforced in relation to form and light.
- Be inventive with your pattern.

Materials: (Chapter 8 page 145)

- Graphite pencil, Charcoal pencil, Conte' pencil, Colored pencil

Note:

If a colored pencil is used, only use it for value and as a narrative element. (Reference Tab #1 page 162)

- Appropriate erasers

The Critique:

Skill Development:

Is your transition from black to white smooth and even? Do your objects appear three-dimensional? Have you maintained the illusion of form, light, and pattern? Does your pattern read as a part of the form?

Chapter #5
Drawing Assignment #2

This is a Narrative drawing that states a personal preference through an Arranged Space Still Life. It is drawn using scumbling in a ***Line, Shape, and Value in Transition*** Marking System. Consideration is given to the way a **Fast** or **Slow Space** can be achieved through the point of view. Point of View and the accurate translation of three-dimensional space are aided by the use of a view finder. **Intensity** is added to Quantity, Size, Edge, Direction and Complexity as a factor for consideration in visual weight.

Skill Development:

With the aid of a view finder, sketched line is used to establish the composition and to accurately describe the subject matter and the illusion of Three-dimensional Space. The image is rendered using a *Line, Shape and Value in Transition* Marking System.

Note:

Using a Sketched Line to develop the composition and to solve the issues of proportion and accuracy, before beginning to render, separates the drawing problems from those of rendering. Working in this order keeps the image more flexible in the early stages. Changes made after rendering has begun are more difficult and messy. However, changes that need to be made in order to make a better drawing should be made at any stage in the drawing.

Concept:

This is a Narrative drawing that is based on a statement of personal preference.

A Statement of Personal Preference

As members of society we are to a greater or lesser extent, defined

by it. We wear the clothing, talk in its terms, eat the food, and own a selection of the things that are a part of the time and place we belong. However, within all of this belonging, there remains a multitude of choices within a wide range of categories that we do make. Making these choices is one of the ways that we express our concern for a personal identity, our individuality. These choices are our personal preferences.

Composition:

This is an **Arranged Space Still Life** drawing with a composition that supports an image that states a personal preference narrative. Point of view is established with consideration being given to a **Fast** or **Slow Space**. **Intensity** (Reference Tab #3 page 177) is used as one of the factors for creating a balanced and interesting composition.

Arranged Space Still Life

In an Arranged Space Still Life the subject matter is selected, arranged and lit to attain the desired visual appearance and content. In Chapter 5 the Still Life was arranged to promote the Formal content of the image, whereas in this drawing, the Still Life is arranged to establish a Narrative statement, one of personal preference. Again, consider the role Symbolism and Visual Synergism can play in a Narrative image.

A drawing that is an illusion of a spacial plane has added considerations, i.e. it is more interactive, "real," for the viewer. It is always an open composition and an open composition suggests that it is a segment of the viewer's space, actively engaging them, consciously or unconsciously. There is a "this is real" sense to the image, a suggestion of involvement.

A spacial illusion also provides two basic narrative potentials, they are metaphorical references that suggest time, and/or priority. Both considerations are related to distance, near and far. To develop priority an image can be constructed to suggest that the things in the foreground are more important than those that appear farther back, or conversely

those things in the background are longed for, lost or forgotten. Time is suggested by the movement into the image, the present is in the foreground and the space is receding into the past or the future, depending on the narrative.

Point of View (Fast Space, Slow Space)

The point of view that is established in a Still Life determines the "speed" that the viewer passes through the space. Lower the point of view and the speed increases, it takes less time, because there is less space to see. A fast space image has a shallow space. Raise the point of view and the speed decreases, it takes more time, because there is more space to see. A slow space image has a deep space. The "speed" of the image influences both the content and type of viewer involvement.

Fast Space
Point of View (low)

Slow Space
Point of View (high)

Intensity and Placement
Now?
Priority?

Intensity and Placement
Later?
Desired?

Note:

Again, these are not absolutes, they are tendencies.

The kind of space an image has plays a major role in the way it is read. A deep space composition is more passive than a shallow space. In a deep space composition the viewer is less active and more of a "what do I think of all of this?" spectator. Whereas a shallow space is more personal and keeps the viewer directly involved, a "what are we doing here" participant.

Note:

In images with three-dimensional space, Visual Movement and "speed" are established by the spacial arrangement of subject matter and the point of view.

Visual Movement (Spacing, Poetic or Prose Arrangement, Cultural Read), as discussed in Chapter 4 with respect to a two-dimensional composition, also apply to an image that is an illusion of three-dimensional Space.

Intensity

In this drawing, Intensity, the last of the factors for developing visual weight, is considered. It, along with Size, Quantity, Edge, Direction, and Complexity complete the group of factors that develop visual weight. (Reference Tab #3 page 177)

Note:

Now that the visual weight factors have been presented it is recommended that you review them frequently. They are the foundation of your composition.

Intensity increases and gains visual weight as value becomes darker, or in color, the color becomes more saturated. (Reference Tab #1 page 162)

Intensity can be used to make a particular part of the image play a more or less important role in the overall content of the image. The intensity of any part of the image is relative to the intensity of the rest of the image. The more intensity that a part of the composition has, the more attention it demands, and the more attention it receives, the more influence it has on image content.

Note:

Intensity could be the defining characteristic of a drawing. A drawing can shout with its intensity or it can be as light and simple as a whisper with many definitions in between.

Of the factors that develop visual weight, Intensity and Complexity are the only components that can vary or be changed without rearranging the composition. Increase or decrease the Intensity or Complexity of a particular part of a composition, and the visual weight changes while the arrangement stays the same. To change the other factors, Size, Quantity, Edge or Direction, one must arrange the composition differently.

As well as factors in visual weight, Complexity and Intensity are also spacial devices (definition and clarity). (Reference Tab #5 page 183). In addition to their enhancing or diminishing the subject matters influence, they present possibilities for suggesting an "emotional context" for the drawing. An image can have a crisp severity with complete definition and clarity from foreground to background or it may be timid, ephemeral, not quite there, with little definition or clarity. There are numerous possibilities between these two extremes and the right variation can make it one of the defining characteristics of a drawing.

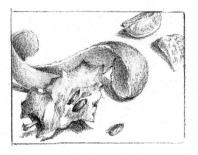 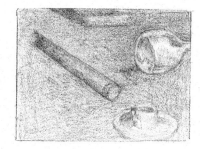

Idea possibilities:

"I prefer this type of," "I like… weather, season, food, clothing, sports," "I really prefer this to that," " I like equally," Consider taking an attitude for this drawing that is different from any you have thus far pursued. Have you considered: humor, irony, sympathy, anger?

Procedure:

- Consider possible ideas and subject matter.
- Draw (20- 40) thumbnail sketches that suggest possible setups for your idea.
- Use 3-5 objects
- Set up your still life using your view finder. Doing the thumbnail sketches while arranging the set up allows you to quickly review a variety of possibilities.
- Consider several points of view and their effect on the composition.
- Select and transfer your composition to your drawing sheet.
- Begin the drawing with your sketched line.
- Working from a light linear sketched line begin the rendering process with a light scumbling.
- Bring the whole drawing up from a light value to the darkest values with an even and steady progress.

Materials: (Chapter 8 page 145)

- Graphite pencil
- Charcoal pencil
- Conte' pencil
- Appropriate erasers

The Critique:

Skill Development:

Does your rendering work to create the desired illusion? If you altered the overall value of your drawing (a whisper or a shout) as part of the content, were you able to successfully alter accordingly your marking system and have it still read?

Composition:

What did your composition do to reinforce your narrative? What role did a "fast" or "slow" space play in your drawing? How did you use intensity in your composition? What other factors for visual weight did you use? How well does your illusion of three-dimensional space read? What advantages did you find to setting up your composition as a still life? What made your composition interesting beyond what you had "planned?"

Content:

Did your drawing convey a visual statement of your personal preference? Were you able to make your statement in a way that was interesting and not blatant? How did you use the formal aspects of your drawing to create meaning?

Always Considered:

What would have made it a better drawing? What did you learn from this drawing? Where are the weak spots in your drawing and what do you think you can do to improve upon them?

Chapter #5
Drawing Assignment #3

This is a Narrative drawing that makes a **Statement of Social Concern**. The image is developed using Scumbling, and **Blending**, and in a *Line, Shape, and Value in Transition* Marking System. It is a **Constructed Space** drawing where the space is developed, as opposed to being observed, through the use of the basic principles of spacial illusion: **Overlapping**, **Linear Perspective**, **Atmospheric perspective**, and **Picture Plane Placement**.

Skill Development:

In this drawing, **Blending** is used with scumbling in a *Line, Shape, and Value in Transition* Marking System.

Blending

Blending is the physical act of "smudging" with your fingers, a paper stomp, or a chamois cloth (Materials: Chapter 8 page 145) in order to smooth (blend) a group of values into one even value or to smooth (blend) a transition from one value to another.

Blending is a natural extension of scumbling. When blending is incorporated in the scumbling process there is a lessening of the textural quality that is part of both linear and textural scumbling. This softening gives the drawer the ability to adjust the relationship between the marking texture and softness in the drawing. There is a mellowing effect on the drawing as the marking texture decreases. One can manipulate the texture of the scumbling to increase, lessen or eliminate the contrast.

Blending

 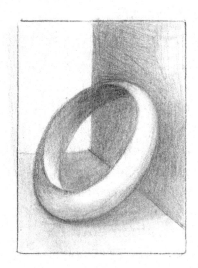

Concept:

This a drawing that makes a statement of social concern.

A Statement of Social Concern (A Political Landscape)

As well as our independence and individuality within society, most of us want to be, in some way, an active part of it. We feel both the desire and the responsibility to help define it. These are our public politics, they are the concerns we have for and against the issues and ideas that are present in our society at a given time.

Note:

A statement of our personal politics is a concept that needs to be Formally compelling and Narratively explicit. One does not want their politics to be misread nor do they want them to be so blatant that the image is overpowered and the viewer simply agrees or does not, but never really looks at the image. The image needs to be compelling enough to hold the viewer's attention and clear enough for them to get the point. It must have an interesting idea, be composed well, and be drawn with authority. This is, of course, true of all good drawings.

Consider the public issues that concern you at this time and in this

place. They may be local or international, big or little, immediate or long range, but they need to be real, public, and something that you really care about.

As in assignment #2 you are asked to consider giving your drawing an attitude that differs from one you have already expressed. The right attitude (sarcasm, humor, dead serious) can have a strong impact on the content of your image. As you consider the attitude for your drawing keep in mind that it will be defined by your choice of subject matter, visual synergism, and the way you develop your space.

Composition:

This a Narrative Drawing with a **Constructed Space** that is developed through the basic principles of spacial illusion: **Overlapping, Linear Perspective, Atmospheric Perspective,** and **Picture Plane Placement.** (Reference Tab #5 page 183). Consideration is given to the development of the **Rate of Transition** and the choice of **Picture Plane.**

Format

Constructed Space

Assignment #2 was a Still Life drawing, a drawing from "life." But unlike that drawing, this one is constructing the space, "as in life." Construct Space allows one to create spacial illusions that would be impractical or impossible to set up. The space in a Constructed Space drawing is intellectual. It is not seen, it is made up, constructed one piece at a time, through the use of the spacial devises: Overlapping, Linear Perspective, Atmospheric Perspective, and Picture Plane Placement. These devises provide a base for drawing both an imagined and an observed space. In this drawing you will use these devises in their most basic definition: overlapping, size relationship, clarity, and picture plane placement.

Overlapping occurs when one object is in front of another and partially obstructs the view of that object.

Size Relationship (Linear Perspective) describes the way things appear smaller the farther back they are in space. And the rate that they appear to be getting smaller is constant. We will look at Linear Perspective more complexly later, but for now we want to focus on these two basic understandings.

Clarity (Atmospheric Perspective) describes the way things become less clear, less defined, as they move back in space.

Picture Plane Placement refers to way the space is arranged on the picture plane. In a one plane composition, when one is either looking down or up, the image reads from the bottom to the top: foreground, middle ground, background. In a two plane composition, as in a landscape where the ground is one plane and the sky another, the image reads from the bottom to the top: foreground, middle ground, background, middle ground, background, foreground.

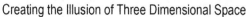
Creating the Illusion of Three Dimensional Space

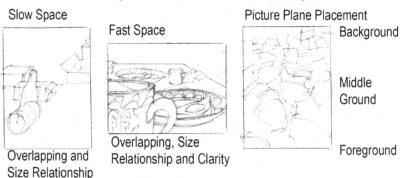

Slow Space

Overlapping and Size Relationship

Fast Space

Overlapping, Size Relationship and Clarity

Picture Plane Placement

Background

Middle Ground

Foreground

Constructing Space

The first issue in composing a constructed space is establishing the point of view. The point of view determines the "speed" of the drawing, its rate of transition.

Point of View

The illusion of space depends on a consistent Point of View

(Reference Tab #5 page 183) and in a Constructed Space drawing this is critical. When creating the illusion of space, by drawing one object at a time, each object is drawn from the same point of view and each one is placed on the same plane (stand, table). In this way they are observed and can be drawn to create the illusion of a believable space.

Rate of Transition (Size)

The rate of transition determines how deep your space will appear and how quickly (speed) the eye will move through it. This is accomplished by choosing one of the objects and using it as a spacial size reference and drawing a light sketch of its size and shape as it changes from a foreground, middle ground, and background position on your picture plane. Using the principle that things appear smaller as they go back in space, the shape of the object is drawn in those three positions in the sizes that correspond to the depth of a desired space. This is purely a visual judgement as they are drawn the size that "looks" right. The rate that they are getting smaller is the rate of transition in that space.

Once you have determined the rate of transition for one object you can use it as a reference for the rest of your objects.

Rate of Transition (Clarity and Definition)

Although the illusion of space can be achieved by using only a transition in size it is a better translation of sight if there is also an equal transition in clarity and definition. Objects become less clear and appear to have less definition, less detail, as they move into the distance.

Picture Plane Format (Horizontal/Vertical)

Picture Plane Format can be neutral, a basic presentation, or it can be a more active part of the image. There is a size relationship (length to width), in both a horizontal and a vertical format, that is so common that it takes nothing from, nor adds to, the image. It simply presents the image. That format is represented in all the post cards, photographs, drawing paper, books, etc. with their slightly varying degrees of a 2 /3

or 3/4 proportion. As the format moves away from these proportions it becomes more and more an active part of the image. Caution is needed here. The format needs to reinforce the image but it can easily take over if the variations become too extreme. One should have a very good reason for changing format, for most images a neutral format is exactly what is needed. However, changing format is a consideration to be made and for the right image, changing the format may be a very good option.

There are reasons for using a format that is out of the normal range. Extending a format horizontally, or vertically, gives the image certain options within the composition. A horizontal format allows for more lateral movement creating the potential for exaggerating issues of balance. It also changes the viewer's relationship to the image. Our sight is by nature horizontal and given a fixed position, our eyes stretch our vision sideways to a greater degree than they do up or down. For this reason a horizontal image is more representational of basic human visual perception. As the picture plane become wider, taking in more than is normal in vision, a panoramic view, the viewer begins to shrink and become less a participant and more a spectator. A vertical format suggests a slightly different context, it is more like a door, an "enter here" where the viewer is on the outside and asked to move into that space. As the picture plane, "the door," becomes narrower, the more the viewer is kept on the outs and the image moves from invitation to exclusion. These are subtle issues and, as such, are potentials and not formula.

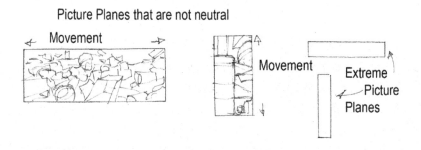

Picture Planes that are not neutral

Idea possibilities:

"Junk Scape," "Food Scape,'"The Environment," "Poverty," "Wealth," "Race," "Gender," "Government," "Health," "War"

Procedure:

- Consider idea possibilities and collect still life materials.
- Select an appropriate sheet of drawing paper.
- Do a page or more of thumbnail sketches that explore your ideas about a "Political Landscape" and possible Picture Plane Formats.
- Select a spot to place your objects that will provide a consistent point of view and establish a plane they are drawn on.
- With reference to the thumbnail sketch that you are using, lightly sketch in the rate of transition, by size for your drawing, using one of the objects.
- Using the found rate of transition sketch in your other objects, draw them one at a time as you construct your space.

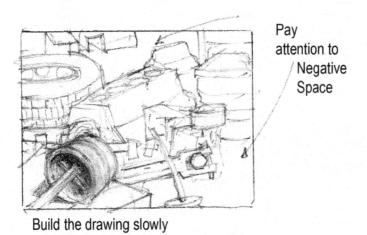

Pay attention to Negative Space

Build the drawing slowly

- Using the *Line, Shape, and Value in Transition* Marking System begin rendering with a combination of scumbling and blending.

Materials: (Chapter 8 page 145)

- One sheet of drawing paper
- Pencil, Stick, Chalk (Charcoal, Conte')
- Chamois Cloth
- Stomp
- Kneaded eraser
- Vinyl Eraser
- Pencil Eraser and or a Retractable Eraser

The Critique:

Skill Development:

Were you able to use scumbling and blending to create good transitions and solid forms? Were you able to blend the values without them becoming too soft and artificial looking? Was your range of value, texture, shapes, or line work enhanced by the process?

Composition:

Does the space you created read as a believable space? What did you do with your composition to create a particular attitude? Is your composition interesting and balanced? What devices for visual weight did you use? How did you determine the appropriate picture plane format for your image?

Content:

Have you maintained your political message while retaining the interest of your image? Is your drawing a shout or a whisper? If your political statement seemed too apparent, how could you have made it less so?

Always Considered:

Did your drawing go beyond your original intentions? Was this drawing a conversation? What surprised you about the way your drawing ended up? What will you try to carry forward in your next drawing?

6

Line, Shape, and Value in Transition (Crosshatching, Stippling) and the Gift

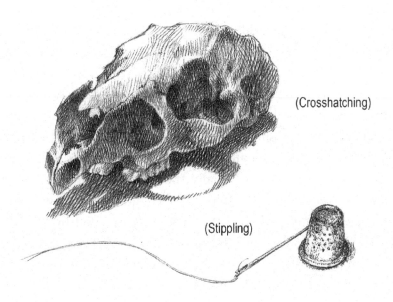

(Crosshatching)

(Stippling)

Chapter 6
Drawing Assignment #1

This is an exercise with four parts. There are two black to white transition exercises, one to practice **Straight Line Crosshatching,** and

one to practice **Stippling**. There are two spheres to be rendered, one using **Contour Crosshatch/Stippling** and another using Straight Line Crosshatching/Stippling, each in a ***Line, Shape, and Value in Transition*** Marking System.

Skill Development:

Crosshatching

Crosshatching requires patience and perseverance. It is one of the most disciplined, if not the most, forms of rendering. Its learning curve is almost vertical, one minute it is going poorly and the next it starts to work. As with all of drawing's skills, success requires practice.

In crosshatching, value gradation is developed in three ways: the distance that the lines are apart, the overlapping of the lines, and the variation of line value. These three techniques are worked together in the rendering process. The first two develop an optical mix where the farther apart the lines are, and the less they overlap, the more the white of the paper shows and the lighter the value appears. Conversely, the closer the lines are together, and the more they overlap, the less the white of the paper shows and the darker the value appears. The value transition is created by gradually spacing the lines farther apart and then overlapping one set of gradually spaced lines with another in progressive "woven" layers. The third means of gradation applies only to media, like graphite, where value gradation is aided by the use of pressure, the more pressure the darker the lines. Using all three means, when applicable, the gradation is developed from light to dark, with overlapping sets of lines. A smooth transition is achieved by stopping each additional set of lines short of the set that preceded it. In order to weave the crosshatching into a linear fabric, that is not just a hectic mass of lines, each set of lines must cross those under it at a variation of acute angles. It is best to avoid a perpendicular relationship with successive lines as they will form a linear grid. A grid is a visual reinforcement of a two-dimensional plane and is opposite to

the desired effect of the three-dimensional illusion that is being developed in rendering.

Because the illusion of form is made by value gradation (Reference Tab #4 page 180) the linear marking of the crosshatching works best when it is in a horizontal relationship to the contour of the form. In that way the marking is in harmony with the form.

Note:

When using a writing grip the lines of crosshatching should be no longer than the length of a palm rotation, or a wrist rotation, if a chalk grip is used. The lines are drawn with a quick movement of the hand, they are not drawn slowly one at a time. A set of lines go down in a rapid progression of parallel lines.

There are two types of crosshatching, Straight Line and Contour. Straight Line Crosshatching builds up its linear weave with straight lines and Contour Crosshatching uses lines that conform to the contour of the form being rendered. Most drawers will naturally use a combination of both.

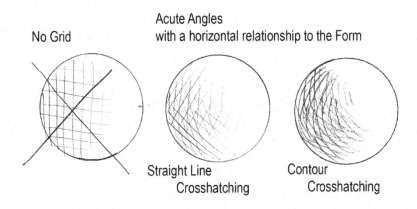

No Grid

Acute Angles
with a horizontal relationship to the Form

Straight Line
Crosshatching

Contour
Crosshatching

Stippling

Stippling is the buildup of small marks (in relation to the size of the drawing) that create an optical mix of dark and light. The more marks

and the closer they are together the less the light of the paper shows and the darker the value that is developed. By gradually making the marks wider apart or closer together a transition is created from light to dark. This transition, used in a value in transition marking system, creates the illusion of form.

The marks used for stippling can be just about anything: a simple dot, a random squiggle, a carefully chosen letter, a symbol etc.

Stippling is often incorporated into crosshatching as a way of giving a smoother transition at the light end of a gradation.

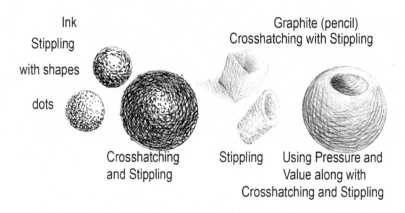

Ink
Stippling
with shapes
dots

Crosshatching
and Stippling

Graphite (pencil)
Crosshatching with Stippling

Stippling

Using Pressure and
Value along with
Crosshatching and Stippling

Crosshatching and stippling are the two means of rendering that can be used with a constant value marking instrument like a pen and ink. Because a constant value medium, like ink, is always the same value, it cannot be made lighter or darker by applying more or less pressure like a pencil.

Note:

Crosshatching and Stippling are almost always linked together in rendering. This is especially true with a constant value media.

Procedure:

- On a small sheet of paper draw two 4"x 4" squares. In each

square create an even transition from black to white from one corner to the opposite. In one square use Crosshatching and in the other use Stippling.

- Build the value transition slowly from light to dark.
- On a small sheet draw two 4" circles. On one circle use Straight Line Crosshatching to render it into a sphere and in the other circle use Contour Crosshatching.
- Build the rendering slowly from light to dark.

Build your Crosshatching slowly one layer at a time.
The layers get progressively closer together (darker).
Each layer ends short of the one preceeding it.

Note:

In crosshatching it is useful to squint (blur the image) on and off during the rendering process. Squinting helps one to see the lines as a value and not just a series of lines.

Materials: (Chapter 8 Page 145)

- Pencil, ink pen, fine felt tip marker
- Start the exercise with a pencil (2H-HB) so that you can get the "feel" of crosshatching. When that starts to feel right move to the ink pens and markers.
- Appropriate erasers
- Choice of sketch book paper

The Critique:

Skill Development:

Is there a woven pattern to your crosshatching or did you lose the weave? Where? Is the transition even and smooth as it goes from black to white? Does your crosshatching flow into the stippling or have you used the stippling to "solve" crosshatching problems? Which feels better for you, straight line or contour crosshatching?

Chapter #6
Drawing Assignment #2

This is a series of drawing exercises that address the basic issues of **One Point Perspective, Two Point Perspective**, and the perspective of **Inclined Planes**. With a basic understanding of these three principals of linear perspective the beginning drawer can confront most drawing situations.

Skill Development:

There are three parts to this exercise in Linear Perspective. Carefully review the corresponding descriptions in (Reference Tab #5 page 183) before beginning each exercise.

Exercise #1
One point perspective

This is a drawing exercise that deals with the basic principles of One Point Perspective. In one point perspective only the depth is receding to a vanishing point.

Procedure:
- Choose a small (small enough to be able to hold it in one hand) cardboard box that has four closing flaps.
- Review the principals involved in One Point Perspective that are presented in (Reference Tab #5 page 183).

- Place the box in a position that is below eye level and with a point of view that places the box directly in front you.
- On a sheet of paper large enough to contain all perspective lines first draw the horizontal line that establishes eye level. While maintaining the point of view draw the height and width. Determine the line that defines the angle, as seen, that references the depth and its rate of transition, the rate at which the depth appears to becoming smaller. Extend that line to eye level and the point where it crosses establishes the vanishing point for the lines that define the depth of the box. Finish drawing the box using visual measurements.
- Repeat the steps above for a box that exists above your eye level. This will require some manipulation with respect to positioning the box. It can be hung from above or attached to a vertical surface to allow the desired point of view.

Exercise #2
Two Point Perspective

This is a drawing exercise that deals with the basic principles of Two Point Perspective. In two point perspective the depth and width are each receding to their individual vanishing points.

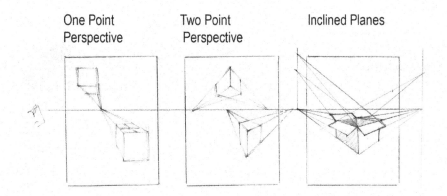

One Point Perspective Two Point Perspective Inclined Planes

Procedure:

- Review the principals involved in Two Point Perspective that are presented in (Reference Tab #5 page 183).
- Using the small box you used in Exercise #1, place it below your eye level and in a position that makes two sides and the top visible.
- On a sheet of paper large enough to contain all perspective lines, first draw the horizontal line that establishes eye level. While maintaining the point of view draw the line that represents the height. Determine the lines that define the angles, as seen, and references the depth and width, their rate of transition, the rate at which the depth appears to becoming smaller. Extend the lines to the point where each one crosses the eye level. This line establishes the vanishing point for the lines that define the box's depth and width respectively. Finish drawing the box using visual measurements.

Exercise #3
Inclined Planes

This is a drawing exercise that deals with the basic perspective principles involved in drawing Inclined Planes with respect to Two Point Perspective. The flaps on a box, when they are not parallel to the edges of the box, are Inclined Planes. This drawing involves drawing the flaps in a variety of position.

Procedure:

- Review the principles related to Inclined Planes and Two Point Perspective. (Reference Tab #5 page 183)
- Using the small box you used in Exercise #1 establish the appropriate point of view below your eye level.
- Open the flaps on the box at an angle that is not parallel to the top edge of the box.
- On a sheet of paper large enough to contain all perspective

lines, first draw the horizontal line that establishes eye level. While maintaining the point of view draw the box, excluding the flaps, in two dimensional perspective as in exercise #2.

- At the vanishing point where the line defining the depth meets eye level, draw a perpendicular line. This line establishes the "wall." Extend a line that defines one edge of a flap, until it crosses the perpendicular line to establish its vanishing point and the vanishing point for the opposite edge of that flap.
- Visually measure the length of the flap, as seen, and from that point extend a line to the vanishing point for the box's edge that is parallel to the corresponding edge of the flap.

Note:

When determining the direction to extend the lines on the flaps, or any Inclined Plane, first determine the closest point to you on the line and extend it into the visual distance.

- Repeat for all four edges.
- Repeat the steps above for a box that exists above your eye level.

Note:

Linear Perspective is one of the means that is used to define spacial perception. It is useful as a tool for both understanding and drawing an observed space as well as providing a spacial structure for invented space.

Materials: (Chapter 8 page 145)
- Pencil HB- B- 2B
- Or the pencil you prefer to use with a sketched line.
- Kneaded Eraser
- Vinyl Eraser

The Critique:

Skill Development:

Do the lines in your drawing that are parallel to one another converge at the same point? Do your lines move toward the vanishing points in a relationship that moves from a point on the box that is near to a point that is farther away? Do your boxes appear to be drawn in proportion with respect to what you see given your point of view?

Chapter #6
Drawing Assignment #3

This is a drawing that develops the concept of **Small Desire** as a **Gift.** It is a small intimate drawing that can be developed around either a Narrative or a Formal focus. It is drawn using **Crosshatching** and **Stippling** in the *Line, Shape, and Value in Transition* Marking System. **Pattern** will be considered as one of the Visual Elements that is used to establish the images Formal or Narrative focus.

Note:

Pattern is technically not one of the visual elements and it is generally considered a repetitive design that has a discernible order. It is, however, for learning purposes, very useful for it to be considered as an element and to modify its definition to any shape or marking, repetitive or not, that conforms to the surface it is on.

Skill Development:

Crosshatching and Stippling are used together in the *Line, Shape, and Value in Transition* Marking System to establish the illusion. The spacial relationships are established through the principles of Linear perspective.

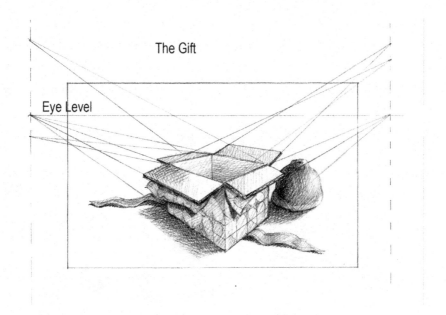

The Gift

Eye Level

Concept:

This is a drawing that uses either a Formal or a Narrative Focus to express the concept of a gift that represents a small desire.

The Gift

This is a drawing that develops the concept of a small desire, one that is expressed as a gift to oneself or to someone special. It is an Arranged Still Life drawing that uses a small box as a container for an object or group of objects. The concept of a small desire as a gift is an emotional response and it can be developed visually with either a Formal or Narrative focus

Formal Focus

When using a Formal Focus, with a small desire concept, it lends itself to the development of the ephemeral context, a visual expression of an emotional response. It is a drawing that has a visual "feeling" that mirrors the desire. It is a less of a purely Formal Drawing and more of a drawing that uses Formal Elements as the characters in the narrative. The drawing uses visual elements to develop responses

that have emotional implications. Warm (color), soft (value), crisp (line), bold (shape), delicate (form), happy (pattern), and tender (texture) are a few examples of possible emotional equivalents. The subject matter is then chosen for its ability to showcase the specific elements.

Narrative Focus

With a Narrative focus the concept of a small desire is a story to be told. As discussed in Chapter #2, the content of the drawing is more dependent on the implicit and explicit content of the subject matter and its compositional relationship. The choice of subject matter is based on the way it will tell the story.

Note:

When considering the Formal and Narrative choices for a drawing one wants to give priority to those that support the focus of the idea. Ultimately, however, the objective is to make both the Formal and Narrative aspects of the drawing as strong as possible.

Pattern

Pattern (Reference Tab #1 page 162), in its ability to be either representational or totally abstract, is capable of serving an image that has either a Formal or a Narrative focus. If the Pattern consists of highly recognizable shapes and characters, like teddy bears and word forming letters, it will readily establish a corresponding narrative content. If the Pattern is a collection of abstract shapes its content will relate more to the "flavor" or "feel" of the image with its descriptive characteristics being dependent on whether it is rhythmic, random, congested, or sparse.

Pattern Crosshatching
Textural Scumbling

Composition:

This is a small Arranged Still Life Drawing where the objects are chosen and arranged for specific formal or narrative considerations. It is a drawing that takes into consideration the issues of size and the use of a border.

Size

The concept of a small desire suggests a drawing that is small in size, an intimate drawing. Small is a relative term and what that actually means depends on a couple of factors. For the beginning drawer a drawing is small if it is smaller than the average drawing sheet and the size goes down from there until it is totally impractical for normal drawing and viewing.

Up to this point size has been regulated by the size of your sketch

books and the paper available. Format shape has been discussed and is now a part of the decisions that go with each drawing. The size of a drawing also has an influence on the way a drawing is "read." There is a roughly average size that is represented in the range of drawing pads and sketchbooks. (9"x12" - 18"x 24") These sizes are by common usage fairly neutral, they do not have much influence on the drawing one way or another. When a drawing is well over or well under those sizes, size becomes an important part of the drawing's content. A small drawing is more intimate because its size brings the viewer physically closer to the image. A large drawing is more immediate and its impact increases as it approaches and surpasses human proportions. There is no hierarchy, neutral, small or large are only of value if they reinforce the content of the drawing. If size is not a strong consideration it is better to leave it out of the equation and keep it neutral.

Borders

While using the whole sheet of paper as the picture plane helps keep composition at the forefront of image considerations, a neutral border is sometime a good choice for a drawing. A border can serve, as a mat and frame does, as a visually neutral space that gives the drawing, and the viewer, a little relief from all that is visually going on around it. A border can also have an effect on the content of an image. A very small drawing on a large sheet of paper with a large border could be making it more precious, quieting it, or giving it the authority of size, depending on the image. There is also the paper itself. Some papers are beautiful in and of themselves, and they lend an overall esthetic to the drawing. A border gives the paper a visual spotlight. And practically, a border gives the drawer something to tape and clip to without interfering with the drawing.

Procedure:
- Consider idea possibilities based on the concept of a small desire as a gift.

- Chose a small box and the objects for possible ideas.
- Do a page or more of thumbnail sketches that explore both Formal and Narrative ideas with consideration given to Pattern, size, and picture plane formats.
- Select an appropriate sheet of drawing paper.
- Select a spot to place your objects that will provide a consistent point of view and establish a common plane. This could be an Arranged Space or a Constructed Still Life.
- On your drawing sheet, establish eye level and draw your box in line using linear perspective.
- Lightly sketch in the composition with graphite in order to solve drawing and composition issues before beginning to render.
- Begin the rendering process using crosshatching and stippling. Work the rendering from light to dark using the *Line, Shape and Value in Transition* Marking System.

Materials: (Chapter 8 page 145)
- One sheet of drawing paper.
- Graphite, color pencil, ink pen
- Appropriate erasers

Note:

Graphite or color pencil are better choices if you are unsure of your crosshatching.

Crosshatching (ink)

The Critique:

Skill Development:

Did crosshatching start to "work" for you? Did your transition become smooth and the form readable? Was there a marriage between your crosshatching and your stippling? Did you choose the right medium for your image and the marking system?

Composition:

What did you do with your composition to create an emotional response? Is your composition interesting and balanced? What devices for visual weight did you use? How did you determine the appropriate picture plane format for your image? What roll did size play in the structure of the image?

Content:

If you chose to work with a Formal image, what were the defining Visual Elements? Did the Formal consideration develop an emotional response? If you chose to use a Narrative image, is the "story" being suggested or was it overly stated with little room for the viewer? How did size and format affect the content of the image? Is your drawing a shout or a whisper? What roll does Pattern play in the content of the image?

Always Considered:

At what point did the conversation begin? What surprised you about the way your drawing ended up? If you developed a Formal image, what were its Narrative possibilities? If you developed a Narrative image, are the Formal aspects of the image as strong as you can make them? What will you try to carry forward in your next drawing?

Line, Shape, and Value in Transition (Choice) and a Place in the Mind

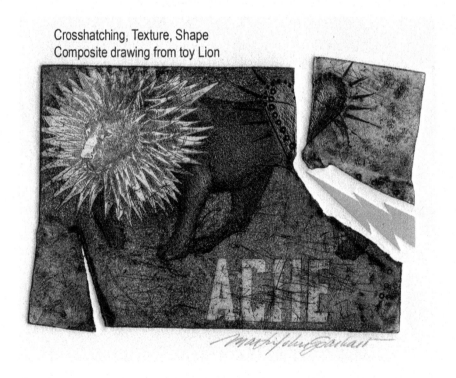

Crosshatching, Texture, Shape
Composite drawing from toy Lion

Chapter #7
Drawing Assignment #1

This assignment includes two **Preparatory Drawings** that are used to solve perspective and compositional problems for the #2 drawing assignment in this chapter. Go to assignment #2 and read the Concept, Composition, Idea Possibilities, and Procedure to understand the issues to be considered in the preparatory drawings. The first preparatory drawing is a small study that is developed to establish the linear perspective for the space that is chosen for the drawing. The second is a full scale preparatory drawing, a **Cartoon**.

The Cartoon

Although the word Cartoon is now more readily associated with newspaper strips and a variety of humorous images, it is also, and was originally, a term for a preparatory drawing that is done full scale and one where the composition and a linear articulation of the subject matter is, for the most part, complete. It is then transferred to the surface that will hold the final image as a starting point for the finished work.

Skill Development:

Exercise #1

This is the initial preparatory drawing used to solve the issues of linear perspective. It is a small drawing with a picture plane that is large enough to accommodate the extension of the perspective lines to eye level.

The Preparatory Drawing

A preparatory drawing is a preliminary study that allows one to isolate and solve drawing considerations like perspective, proportion, and placement before they are brought to the final drawing. While the picture plane of a preparatory drawing needs to be in the same proportions as the image it is in preparation for, it is often smaller and focused on a specific drawing problem.

A preparatory drawing is particularly useful for drawings that are:

composited, complex, have an invented space, need to be drawn from a fixed position (like a particular space), or when the surface that is being drawn on is fragile or erases poorly, and when a permanent medium, like ink, is to be used for the finished drawing.

Procedure:

- Read through the Concept, Composition, Idea Possibilities and Procedure for Assignment #2. Considering your ideas use your view finder to select possible spaces and develop a series of thumbnail sketches.
- From your thumbnail sketches choose an idea to develop and the space that it will include.
- On a sheet of drawing paper with a picture plane, in the proportions to the final drawing, develop your linear perspective study. (Reference Tab #5 page 183) Make your drawing of the space small enough to allow the perspective lines to be extended to an eye level that is on the drawing sheet.

Exercise #2

This is a Cartoon for the drawing in Assignment #2.

Note:

A cartoon is a full scale linear drawing that solves drawing and compositional issues. It is drawn on a paper that is thin enough to allow it to be transferred to a final drawing surface.

Procedure:

- Again read through the Concept, Composition, Idea Possibilities and Procedure for Assignment #2 to review the objectives as they relate to your idea.
- Select a thin dispensable sheet of paper for your cartoon that is large enough to accommodate the actual size of the picture plane to be used for the final drawing.
- Working from the small study that you did in exercise #1 draw

your space, to size, in perspective, and composed the way it will be in your final drawing. If you are having trouble with the perspective you may want to tape the paper to the floor or the wall and use strings to establish eye level and to extend the lines to their vanishing points.

- Working from your thumbnail sketch establish the point of view for each of your pieces of subject matter and draw them into your cartoon using a light sketched line and considering their relationship to the space you are creating. They do not need to be rendered. Just solve the placement and proportion problems. Depending on your idea and the composition required, each piece of subject matter may require its own point of view. The positioning, setting or suspending of the subject matter may require inventive solutions.
- The completed cartoon can now be transferred to the drawing paper.

Transferring

There are several techniques for successfully transferring one image to another. The most basic, and simplest, is to use the sheet being transferred. This assumes that the sheet being transferred is dispensable, as with a cartoon. This technique is accomplished by scumbling the back of the sheet to be transferred with the medium that is going to be used in the drawing. If the finished drawing is going to be in graphite, use graphite, if in conte' use conte' and so on. In order to keep from making a mess of the paper that is being transferred to, the medium needs to be applied as lightly as it can be, and still transfer. A quick test will demonstrate how much is needed. Then the paper to be transferred is laid on top of the drawing paper in the desired position.

At this stage it is advisable to make a set of registration marks on both sheets of paper so that the tracing can be placed in the same position if it is needed at a later date. Registration marks are markings made on each sheet of paper so that they coordinate, line up, with each other. At least three sets of registration marks are needed to establish an accurate registration in both width and height.

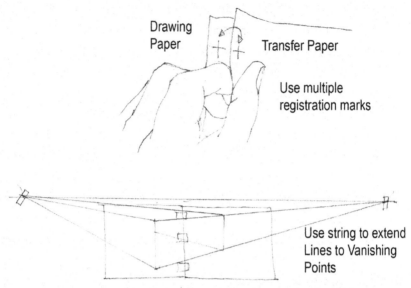

Drawing Paper

Transfer Paper

Use multiple registration marks

Use string to extend Lines to Vanishing Points

Use multiple sheets of Transfer Paper if needed

When registration is established, the transfer can begin by tracing the line with a hard pencil or a (fine) ball point pen. Use as little pressure as is possible. If image being transferred is not dispensable then it can be traced using tracing paper.

- Transfer the cartoon and move on to Assignment #2.

Materials: (Chapter 8 page 145)

- Pencil of choice
- Paper for cartoon
- If the paper available is not big enough you can tape two sheets together. Permanence or looks is not a concern for the cartoon.

Note:

The Cartoon can be worked on any paper that is thin enough for a good transfer and durable enough to allow for the erasing and redrawing that will be required.

- Paper for finished drawing
- Tape
- String
- Ruler

Chapter #7
Drawing Assignment #2

This is a narrative drawing that develops a personal **Fantasy**. The drawing is based on the idea of changing an observed space into a **"Place in the Mind."** It is a **Constructed Composite Drawing** that takes the space developed in Assignment #1 and changes it into an imagined place through the addition of subject matter and decorative manipulations.

Note:

This is the last assignment in the book. Consider it as a comprehensive drawing. Look through your past drawings and remember the things that excited you about them and what they taught you. Then carry that energy and those understandings into this one.

Skill Development:

This drawing will use a *Line, Shape, and Value in Transition* Marking System. The choice of media and mark making process (scumbling, crosshatching, and or stippling) will be determined by the needs of the idea. The possibility of mixing Marking Systems is considered.

Mixing Marking Systems

One can use different Marking Systems in a drawing. However, there needs to be a reason to do so, otherwise the image just becomes confusing. For instance, if in this drawing you decided to use one marking system for the space and another for the things that you place into it, mixing marking systems could work because of the nature of the drawing. It is a drawing where there may be, depending on your idea, two realities coming together, the space and the things you put in it.

Note:

There is a difference between confusion as a concept and a confusing visual language. Consistency makes a language coherent and unless a drawing is supposed to be unreadable, confusing, its visual language should be understandably consistent and that could mean one or more marking systems or media. The important point is that their use be consistent with and help develop the concept of the drawing.

If you choose to use more than one marking system remember that there are three that are basic: *Line and Shape, Line, Shape and Value, and Line, Shape, and Value in Transition,* each with its variations. In order to have a noticeable contrast between marking systems they need to be different systems. If you use two variations on the same system they will have a tendency to blend together.

There are other ways to separate aspects of a drawing. In this drawing for example each reality could be a different color or value.

Concept:

This is a narrative drawing in the category of **Fantasy**. It is a drawing that develops an ordinary space into a place in the imagination, **A Place in the Mind**.

Fantasy

Fantasy is a product of our wondering. It is the fabric that we weave from the unknowns that surface in our day-to-day. Some of our wonder

is about the basics of our daily lives and some of our wonder is about ideas and experiences that seem to be beyond us . We build fantasies around both. In our anticipation we construct a fantasy for tomorrow that is built on the experiences of yesterday and the expectations of today.

In our imagination we give substance to the seemingly unknowable, the world of our day and night dreams. Our dreams drift and float from what is to what is not, stirring themselves into a fragile mental reality. It is union that is at once clear and in a moment unclear, and the next forgotten. In its moment of clarity the dream is an unchallenged twisting of the logical and the illogical into its own reality. It is a place in the mind.

A Place in the Mind

A space is an emptiness that is described by its dimensions, how much it will hold and its configuration. A space is defined by the materials of its structure, and what is put into its emptiness. A place is a defined space.

Consider the spaces that are available for this drawing. It could be the drawing room, an adjacent room, or corridor. These are spaces that are more or less nondescript or purely functional. If they are not, you are going to visually strip them so that you can "remake" them in your drawing. This space is going to become the place of your fantasy. By drawing things into the space, changing its characteristics (wall and/or floor covering, eliminating doors, windows) and choosing how it will be seen (point of view), it is going to become a place in your mind.

Composition:

Composite Constructed Space

This is a Composite Constructed Space drawing. A Composite Constructed Space is a combination of a Found Space and a Constructed Space. This drawing develops a fantasy by selecting a space and

redefining it by manipulating the decor and compositing the subject matter in a manner that reinforces its narrative.

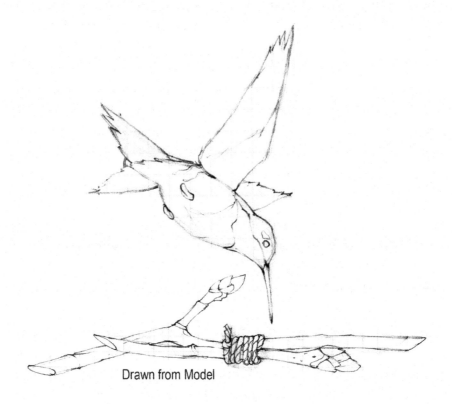

Drawn from Model

Subject Matter

A fantasy drawing can pose a challenge with respect to subject matter. Some ideas will make it almost impossible to use the actual subject matter. In these cases there are often ways to simulate the desired reference. If for example the need is for a body of water, a facsimile can be created with rocks, sand, and a water container. Also, there is almost an endless supply of quality miniature replicas of animals, cars, trucks, equipment, and the like, that can be used as straight subject matter or to build more complex facsimiles. If nothing else is available, there is the photograph. It is not that the photograph is not a valid reference, it is and a vast number of artists use them, but for the beginning drawer it is preferable to draw, when possible, from the fact. A photograph is a

difficult reference because so many of the visual choices are made by the camera. It requires careful consideration of exactly what information one wants from the photograph in order to be able to transcend its characteristics and to be able to use it simply as a reference.

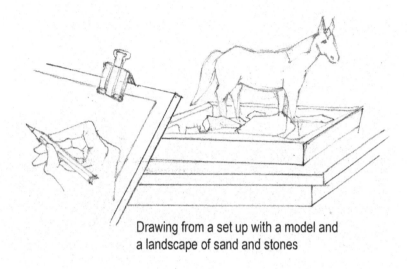

Drawing from a set up with a model and a landscape of sand and stones

Point of View

In an image that is based on a space, which is drawn from observation, point of view has a very strong influence. In this drawing the chosen space will, by description, be common place. It is a situation that we have been in so often that we have almost quit seeing it. One of the objectives of this drawing is to change that. As human beings we are used to seeing these spaces in a fairly routine manner and for the most part we are standing or sitting and looking straight ahead. Most of the time that is our point of view. Change that, even a little, and the whole visual experience becomes fresh and out of the ordinary. What if one is looking at a space with their chin on the floor, or from way above, or looking up, down, really close, from a place no one ever goes, etc.?

Note:

There are habits that each of us develop in our drawings generally because they work for us. They can quickly become formulas, and

then traps, that keep us from growing. Look for these in your work and make breaking them a priority.

Crosshatching used to develop Shape and Texture (Ink)

Idea possibilities:

"What if this were," "What if this place were full of," "If only I could," "My room when I was," "There is all of this going on in here," "What if I were an," "What if they could," "It was like this,"" As I remember that dream," "A place of Fear, Hope, Joy"

Procedure:

- Consider ideas for your "Place in the Mind" and locate some possible spaces and the subject matter for your drawing.
- Using thumbnail sketches consider possible media, sizes, formats, and points of view for your image.
- Go to back to Assignments #1 and #2 and complete the preparatory drawings.
- After your cartoon has been transferred to the drawing paper, begin the rendering process. Work from light to dark and to the

extent that is practical, work the drawing as a whole. Let the drawing grow and change as it suggests.

Note:

At this point the drawing process should be one of the major factors in the growth of your drawing. Do not dictate, but follow and let the drawing take you to its end.

Materials: (Chapter 8 page 145)

- One sheet of appropriate drawing paper. Consider size and media.
- Chose media with consideration given to drawing size and its appropriateness for the chosen mark making process.
- Appropriate erasers

The Critique:

Skill Development:

If you mixed your marking systems or used another means of separating the image's "realities," did it accomplish your goal? Has your rendering improved? Has your hand-eye coordination improved? Make a comparison with your other drawings. How accurate or believable was your linear perspective?

Composition:

What did you do differently in this composition and or format that you have not done before? What habit, if any, did you break? If you used a border, how did it serve your composition? Why did you choose this size for your drawing? Is your composition interesting, balanced?

Content:

How much did your idea grow? Did you "really" leave yourself open to the changes that the process suggested? What were they? Which ones

did you follow? Which ones did you chose not to follow? Why? Was it a good idea in the first place?

Always Considered:

Did you like your drawing? Why? Why not? What ideas did you carry over from past drawings? If you could start again what would you do differently? How did the drawing surprise you? What did you learn? This is the last drawing assignment of the book. Was it your most successful? What is your next step in drawing? What has drawing taught you?

8

Drawing Materials

One can draw with minimal materials and expense without sacrificing quality. The materials and supplies suggested in the chapters of this book cover the learning needs of the beginning drawer. The lessons in this book provide the beginning drawer with a basic knowledge of materials and their usage, an understanding that can be applied to related materials. A look at any Art supply catalog will demonstrate the vast quantity of materials that are now available to the drawer. Seeing all those possibilities can be exciting and at the same time it can be over whelming, until one realizes that it all falls into some very basic categories of description and use.

Drawing instruments:

Pencils

Pencils come in almost all drawing media. Graphite, Charcoal and Colored being the most common.

Note:

The media consists of the specific medium (like graphite,) a substance to hold it together (binder,) in some media an agent for fluidity (grease,) and often a filler (less expensive products.)

The pencil comes in a variety of shapes and constructions ranging from the regular wooden pencil to the mechanical. As a drawing instrument the pencil offers a variety of conveniences. Its wooden (or other material) exterior protects the medium in the core and makes it relatively clean to carry and to use, as well as making it possible to sharpen the core to a fine point. In some media the core is still quite fragile and needs to be hand sharpened while supporting the core.

Several types of pencils have erasers built in making them handy for holding a sketchbook in one hand and drawing/erasing with the other.

A pencil is generally held, as in writing, with the drawing hand supported on the drawing surface. When drawing in this manner the hand is moving on the paper during the drawing process and requires a protective sheet under it. The protective sheet must remain still while the hand moves on it or it will smudge the drawing. When standing while drawing at an easel a pencil can be held in a chalk grip.

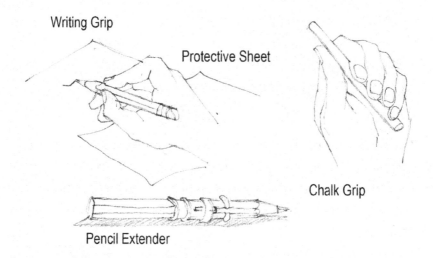

Writing Grip

Protective Sheet

Chalk Grip

Pencil Extender

In most circumstances and there are always exceptions, the pencil works best with small to medium large drawings. Size, however, is always an issue when using a drawing instrument.

Drawing Size

It is a bit arbitrary to say what a large drawing is as it depends a lot on the image, marking system, complexity and media of the drawing. An 8″x10″ pen and ink crosshatched drawing of a complex image may be considered large for that kind of drawing while a 8″x10″ compressed charcoal line drawing would be considered small. It is also possible that for the right idea and circumstances a drawing could/should be done microscopically or so large it could only be viewed from an airplane. That understood, we will however, for the purpose of learning to draw and an awareness of the norm, consider a drawing 18″x 24″ to 22″x 30″ as large.

The size of your drawing will influence your choice of media and marking system. One must consider the size relationship between the mark that is made by a media and how it relates to the size of the drawing surface. A pencil line on a small sheet of paper is a formidable mark while on a very large sheet or a wall it has little impact. A chalk line on the other hand would retain its presence on a large surface. These choices, of course, depend on what the drawer wants from the drawing.

A small line on a large surface will have a tendency to bring the viewer closer to the drawing, something that may be desired for a more intimate image. A bold line will project and give the read of the drawing more distance and a visual "shout."

Note:

The drawer wants the content, media, marking system and size to all work towards the same end. Pencils, Sticks, and Chalks will work with all the marking systems if the size of the drawing is appropriate. Inks require a linear marking system or, if rendering, crosshatching or stippling.

Stick

A stick is a medium (charcoal, conte', graphite) that is held together by some type of binder (glue) and formed into a square or round "stick." It is basically the same thing as the pencil's core of the corresponding medium only without the supporting covering.

Vine Charcoal is an exception to this as it is actually charcoal, a burned vine. Because a stick lacks a cover that provides much support, it is held together by its binder, and is thicker than a pencil core. This thickness means that a stick will make a larger mark or line. It can, however, be sharpened to give it a fine drawing edge. This is done by either cutting or sanding it at an acute angle. Like fragile pencil cores, a stick needs to have support under the end being sharpened.

In the drawing process a stick is most often held in a chalk grip and the drawing is done with a full arm movement. There are holding devices that can be used for extensions on short pieces and that will allow the stick to be held and used as a pencil.

Chalk

In drawing the most commonly used chalks are compressed charcoal for black and white drawings and pastels or oil pastels for color.

Chalks, like sticks, are made with a medium and held together with a binder. A chalk is generally softer because it has more of the medium and less of the binder. This ratio generally gives chalks a richer

pigmentation (a deeper black and more saturated color) than that of a stick or pencil. It also makes chalk more fragile and they are made larger in girth to compensate for that weakness. Although a chalk can be "sharpened" in the same fashion as a stick, its softness will not hold an edge very well. For that purpose most drawers will use either a stick or pencil of the same media.

Pens and Points

There is a large variety of pens and points that are now available. The array goes from the traditional drawing points with their accompanying handles through lettering pens, fountain pens, ball point pen, and on to a whole assortment of markers. The marks that they make vary from one pen to another in thickness and thinness. The felt tips and ball point pens will give the drawer a mark that has a consistent width while the drawing points, lettering pen and fountain pen will react to pressure to produce a line that can vary in width. Although the ink in the pen is of one value, a line that varies in width will appear to change value as it goes from thick to thin.

Media:

Graphite

Graphite is silver gray to black in appearance and at its darkest retains a metallic shine. It is an excellent medium for line, blends well and is, in one of its forms, excellent for all marking systems. It adheres well to the paper and does not easily smudge in its light and middle values (a real asset for sketchbook work). In the darker values and on drawings that have many layers, graphite needs a fixative or, preferably, to be matted and framed for protection.

Graphite is best known for its pencil form. Of all the drawing media the graphite "Lead" pencil is the most common and probably the most used. Graphite also comes in a stick and powder form.

It is graded by its range of light and dark values. The pencils are sorted by numbers and letters that go 9H, 8H, 7H, 6H, 5H, 4H, 3H,

2H, H, F, HB, B, 2B, 3B, 4B, 5B, 6B, 7B, 8B, 9B. H stands for the light values and B for the dark. The higher the number, the lighter or darker the value. The lighter the value becomes the harder the graphite and conversely the darker the value the softer the graphite. Drawing pencils are labeled (embossed) accordingly. The stick form comes in 2B-4B-6B and the powders are generally not graded and vary slightly but are in the HB- 4B category.

Graded drawing pencils are predictable in their value reference and give the drawer a wide selection from dark to light. There are, however, a whole group of "regular" pencils that are much less expensive and that have a value range that is about 2H- 2B. They are, if at all, labeled #1, #2, #3 or simply hard, medium, soft. A #2 or a medium is about an HB. There is no apparent standard so one needs to test them, from brand to brand, to see how they perform.

Charcoal

Charcoal ranges from a warm gray to a deep cool black. Of the black and white drawing media it is the richest and offers the greatest range of value. It is available in a wide assortment of sizes and shapes, works well with all marking systems, and is an excellent choice of medium for both small and very large drawings. It is a very versatile medium. In its lighter values it sits a little tentatively on the paper, while, in its dark values it is fairly tenacious and can be difficult to erase. Because it smudges easily charcoal is less desirable than graphite, color pencil, or Ink for the sketchbook.

Vine Charcoal

Vine Charcoal is the "fluid" form of the Charcoal medium. It goes down with ease, is moved around freely, blends well, and erases easily. In appearance Vine Charcoal is a warm gray that can be layered to a black. Vine Charcoal sits lightly on the paper making it fragile and needing to be sprayed with a workable fixative during the drawing process in order to give it a stability. A workable fixative allows further work to be done on the drawing.

Note:

Even after a drawing is sprayed with a fixative it needs to be handled with care.

Compressed Charcoal

Compressed Charcoal on the other hand is "sticky," it holds tightly to the drawing surface, blends well, and erases more stubbornly. Compressed Charcoal is cooler and goes down in a deep rich black. The difference in the characteristics of Vine and Compressed Charcoal, when used separately, make each one the right choice for certain kinds of drawing. Vine charcoal lending itself to a light and fluid drawing while Compressed Charcoal lends itself more to a dark and bold drawing. They also work well together. Vine Charcoal is an excellent media for the first stages of a drawing where one is solving compositional and drawing problems while adding Compressed Charcoal during the final stages of the drawing can give it rich blacks and add range to its value scale.

In the pencil form charcoal generally comes in a hard, medium, and soft distinction or if they are labeled the numbering will be similar to that of graphite.

Color Pencil

Note:

Colored pencils are listed here as an option for single color drawings that address value and emotional color.

Color pencils come in about any color imaginable and one can buy them everywhere. There is, however, a wide range of quality in all of this quantity. Look for those that say something about the quality of their color or better those that give some reference to the stability of their different colors.

Note:

Colors have very different degrees of stability and permanence. If you are concerned about this it is best to use colors that have been tested and are labeled with the results.

The core of a color pencil is a combination of color pigment, a wax like binder, and filler. In general a high quality colored pencil has more pigment and less filler. Drawing a few lines with a colored pencil will give one a good sense of its quality. A quality color pencil should "grab" the surface of the paper and leave a solid line of saturated color.

Color pencils do not smudge or blend easily, because of their wax base, making them a good tool for the sketchbook. However, they do not erase as well as graphite, so for the sketchbook it is a toss-up between the two. Because the wax base makes blending difficult transitions in value are best achieved through scumbling, crosshatching, or stippling.

Conte'

Conte' comes in both the pencil and stick form. It is available in a variety of earth colors and black and white. Burnt sanguine (rust red) being the most common. Conte' is similar to a stick charcoal in character and, although it is not, it is often listed as a charcoal. When conte' is labeled it is graded in the same system as graphite.

Ink

The variety in inks ranges from that in the "everywhere" pens to those that are made especially for drawing, writing, and painting. The standard writing pens, those that are not refillable, while convenient, do not give much information about their color fastness (color change with time) or their permanence. One uses them with that understanding. The ink in these pens generally comes in some variation of the standard, black, blue, red, and green. The inks available for pens that can be filled by the drawer provide a whole spectrum of colors and many provide information on their color fastness and permanence. Along with these colored inks there are the dyes and liquid watercolors that will work well with most pens.

Erasers:

Erasers come in a variety of sizes, shapes, and materials, from the one on the end of the common pencil to the electric models. The erasers job is to remove the medium without ruining the drawing or damaging the drawing paper.

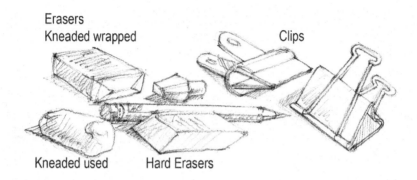

Erasers
Kneaded wrapped

Clips

Kneaded used Hard Erasers

Note:

There are two general cautions that apply to erasers. There are erasers that become brittle/hard with time and instead of erasing they smear the medium and stain the paper, and there are colored erasers that leave a tint of their color on the paper when used. Always test an eraser before you use it.

Although there are many types of erasers to choose from there are two basic types that best meet the needs of the beginning drawer. Each type has its own specific purpose.

Kneaded Erasers

Kneaded erasers are the most versatile of the drawing erasers. They are a putty like eraser that is kneaded (stretched/pulled) during use. They become hand warm and can be formed to the size and shape

required to do the job. The kneading adsorbs the erased medium, giving the eraser a long life. They can be used in the normal manner of scrubbing on the surface to remove the medium or they can "lift" away the medium. This is accomplished by pressing the kneaded eraser down on the spot to be removed and then quickly pulling up, "plucking" or "lifting" off the medium. This technique works well for tight areas, areas of heavy rendering that would smudge if scrubbed, and it is the most effective way to remove or lighten colored pencil.

Solid Erasers

Solid erasers include vinyl, rubber, and gum erasers that are available in a large assortment of shape and sizes. These are the "scrubbers" and are made to remove all the medium and bring the paper back, or close to, its original state without overly stressing the surface. Some work better than others, depending on the paper and the media, so some testing is in order.

Although the typewriter is a thing of the past the typewriter eraser is still available. A typewriter eraser contains a fine grit and is very aggressive. They come in a variety of sizes and shapes. These are the "diggers" and they will literally remove part of the paper, as if sanding it. There is one more step that can be made in erasing and it is sanding, the final option. Sanding is done with a fine sandpaper (150 grit- 220grit) both sanding and "digging" require a great deal of caution because they are removing paper and it is all too easy to create a hole. After sanding or digging one should clean the area with a kneaded eraser and burnish it by rubbing (apply pressure) it with a smooth hard object that will not discolor the paper, like a stainless steel spoon.

Blending Tools:

Chamois Cloth

Chamois Cloth is a small (2"x 3" or so) cloth that is used to both remove media and to blend it depending on the need of the drawing and the condition of the chamois. A new chamois will remove media as

well as blending it, while a used one, one with a fair amount of media permanently on it, will blend more, remove less. A chamois that is full of media (dirty) can be used as mark making tool.

A true Chamois Cloth is not a cloth at all but a piece of tanned goat's hide. It is most commonly used to dry off a wet automobile. For this reason it is often available in the auto supply section of stores. One chamois can be cut into several small ones. Make sure you buy a real chamois and not an artificial one.

Stomps

A Stomp is a rolled or compressed paper stick that comes in a variety of sizes and is pointed on one or both ends. It is a blending devise that works particularly well in tight and small areas of the drawing. A dirty stomp, like a chamois, can also be used as a marking tool.

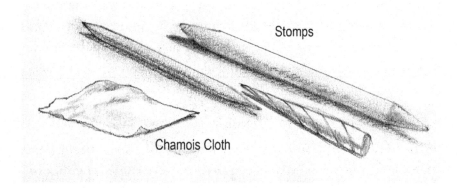

Stomps

Chamois Cloth

Paper:

The variety of drawing papers available for drawing is large and varies from manufacturer to manufacturer. These papers will fall, for the most part, into two general categories of concern for the beginning drawer, bonded papers and mold made rag papers. Both come in single sheets, pads, and illustration board. Pads come with multiple sheets of paper and are hinged in various way, allowing them to be hand held while one is drawing. Illustration board is thick and rigid enough to be held without support.

Bonded Paper

Bonded Paper is a composite paper that used to be made primarily out of wood pulp giving it a high acidity and making it very impermanent. That is no longer the case as the composition of bonded papers now varies greatly. The chemistry of composite paper is now much more sophisticated and many are acid free, suggesting better longevity. Most sketchbooks contain a bonded paper. With the improvements in bonded paper, the variety, and the fact that it is less expensive makes it a good option for many types of drawings.

Rag Paper

Rag Paper is just that, paper made from rags, mostly cotton. Cotton is still the major component in rag paper but it has also been refined over the years. Most rag paper is mold made, meaning that it is literally poured into a mold to be formed. You can generally tell a mold made paper by its ragged (deckled) edge and the way the paper's brand name appears. Most rag papers have their brand name, in one or more corners, either embossed on the surface or molded into the paper in a manner that allows it to be seen when the paper is held up to the light.

Note:

The "front," or preferred side for drawing, of a sheet of rag paper is the side where the brand name reads correctly. However either side may be used.

Rag papers are generally classified by the way their surface texture is formed. Rough is the name given to the paper as it comes out of the mold. Cold Press is a rough sheet that has been run through a press cold. Hot Press is a sheet of rough that has been steamed and run through a press hot. In drawing Hot Press is probably the most used and versatile of the rag papers.

If the look of rag paper's mold created deckled edge is desired, the sheet is torn to size instead of being cut.

Tearing paper to create a deckle edge

Bonded and Rag drawing papers are defined by their: intended use, surface texture, thickness, size, and color. Choosing the right paper for your drawing will depend on the way these various factors serve the needs of your drawing, how much you can spend, and what is readily available.

Both rag and bonded papers are often listed by their intended use. While this does give one some indication of the papers properties it is not a statement of limitation. Probably as many finished drawings are drawn on watercolor and printmaking papers as are drawn on those listed for drawing

All papers have a surface texture that will vary from very smooth to heavily textured depending on paper. In general a linear marking system works best on smoother surface and a value orientated marking system will work with most surface textures. A marking system that uses textural scumbling requires light to heavy texture in order to develop its value scale. Pen and ink drawings that use steel quill points require a smooth surface to allow the points to move freely without catching and spitting ink. Most drawings can be done on the smooth to lightly textured paper which is found in the majority of drawing pads.

Note:

To some extent the more texture a drawing paper has the more that texture influences the read of the image. A smooth texture is neutral and as the texture increases it plays more of a role in the image. Whether this is good or not depends on the objectives of the drawing.

Paper thickness is generally defined by how many pounds 500 sheets (a ream) of a particular paper would weigh. A 140 lb. sheet of paper means that 500 sheets of that paper weighs 140 lbs. A 300 lb. sheet of paper of the same kind and size would be about twice as thick as a 140 lb. sheet. Most drawings are done on paper that is in the 50 lb. to 140 lb. range.

Papers come in a full spectrum of colors, tints and a wide assortment of warm and cool whites. When choosing a colored paper one needs to be certain that the color fastness (how fast it will fade) meets their needs and expectations for the drawing. Some colors fade very quickly.

In size paper can be purchased by the yard, in rolls that are over six feet in height, or in pads that are as small as 3" x 4." Small sheets can be bonded to create larger ones or large sheets can be cut or torn to make smaller ones.

Note:

Not as a deterrent, but as something to be understood, one must remember that as a drawing increases in size the practical problems of process, presentation, and preservation increase greatly.

Accessories:

Sharpeners

Depending on the media and the type of instrument, the sharpening process will entail one or more of the following devices. There are wall crank, electric, and hand-held sharpeners for pencils, single edge razor blade, a utility and x-acto knives for stick and chalk as well the use of

sand paper (150-220 grit works best) and other abrasive material for all of them.

Drawing Boards

A drawing board can be as complex as a commercially constructed board that has a handle for carrying and with clips to hold drawing paper or it can be as basic as a piece of 1/4 inch Masonite used with masking tape or clips. It just needs to be smooth, solid, rigid, and, depending on the size and type of drawing, light enough to carry.

Masking Tape

Masking tape comes in a variety of sizes and with an adhesive that is made for specific purposes. Drafting tape is made for use on drawings. It has an adhesive that is designed to eliminate the tearing of the paper when removed. Regular masking tape can be used if it is "de-tacked" by first sticking it to the pant leg and removing it a few times to lessen the tack. There is also a long stick masking tape that will not dry out as quickly as a regular masking and it can be used if the tape is going to be on the paper for a long period of time. It is not made specifically for drawing and may also need to be de-tacked. Always test before using! Unless stated most masking tapes are not acid free and should not be left on the drawing for an extended period of time. It is always a good idea to remove the tape as soon as is possible.

Clips

When it is possible Bulldog and Binder clips are a better choice than tape for holding down the paper. With clips there is no risk of a chemical exchange between them and the paper.

Fixative

In order to keep a drawing in heavy pencil, stick, or chalk stable, as it progresses and after it is finished, one needs to spray the drawing with a fixative (fix the drawing). A workable fixative is preferable, even for a finished drawing, because it leaves the drawer the option of change

and is less harsh. At best a fixative sets the drawings media so that is will stay put given minimal abuse. It is not a permanent solution that is accomplished by matting and framing the drawing. The fumes of most fixatives are toxic so a drawing needs to be sprayed in a well ventilated area. Read the can for specific instructions.

9

Drawing Fundamentals:
The Reference Tabs

This chapter is an introduction to fundamental definitions, concepts, and applications that are basic for one who is learning to draw and learning to use drawing as a mode of thought. They encompass issues and considerations that arise in every drawing. Any one of these considerations could in itself be an extensive study, but here they are presented as they apply to the needs of the beginning drawer.

In order to make them readily accessible they are set up as a tabbed section.

Reference Tab #1
The Visual Elements

As in a verbal language, where there is a limited number of components like nouns, verbs, and adjectives that are arranged to create an understandable form of expression, the visual language is also developed through the consistent use of a group of components that we call the Visual Elements. The Visual Elements are: Line, Shape, Value, Texture, Form, Space, Color, and for the sake of the beginning drawer, Pattern, which is not technically a Visual Element. In this book Color will be approached in a very limited manner. Its complexity is best approached after one has an understanding of other drawing basics.

Note:

Pattern is technically not an element but it is useful for the beginning drawer to consider it as one.

The eight Visual Elements are <u>all</u> the components for drawing, no more, no less. When we make a two dimensional image we are arranging and combining these elements, or their illusion, in a way that conveys our desired visual statement.

Each of the elements has its own attributes and those attributes give it its visual characteristics. Alone or in coordination with other elements these visual characteristics are used in a drawing to define and energize the image.

To Define: Definition is the practical or the working, aspect of the visual elements. It is where separate elements come together, each playing its part, to form an understandable visual reference to what is being drawn.

To Energize: Each Element has characteristics that lend a visual interest, based on variations of harmony and contrast, to the image. These characteristics are interesting because of the way they look, independent of what is being described or the manner in which they are drawn (the marking gesture).

Note:

Contrast, where things vary in degrees of difference from one another, and/or Harmony, where things share varying degrees of likeness, are basic components of interest and coherence in a drawing as they are in life.

LINE

Line is a connected series of points. Line is the most basic of the drawing elements. Line was our first scribbled introduction into the world of visual expression and it is line that has predominantly filled the sketchbooks of Artists across time. Line is the workhorse of drawing.

Characteristics: variations in thickness, value (variations of light and dark), application (delicate to aggressive)

Types of Line

Objective Line:
 A line that has a constant width and value

Subjective Line:
 A line with a rhythmic variation of width and value.

Sketched Line:
 A "sketched" line that maintains the rhythmic variations of width and value while it "searches" for shape, proportion and placement.

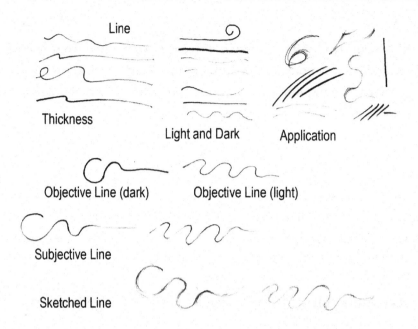

Line

Thickness

Light and Dark

Application

Objective Line (dark)

Objective Line (light)

Subjective Line

Sketched Line

SHAPE

A two-dimensional area that is described when a line connects to itself or, if the line is not apparent, a shape is defined by the edge that encloses it.

Characteristics: size relationship (harmony or contrast), nature (geometric, organic)

Type of Shapes

Positive Shape

A shape that describes two-dimensionally what is, i.e. the things of substance on the picture plane.

Negative Shape

A shape that describes two-dimensionally what is not, in other words, the places on the picture plane that are between and around the tangible subject matter.

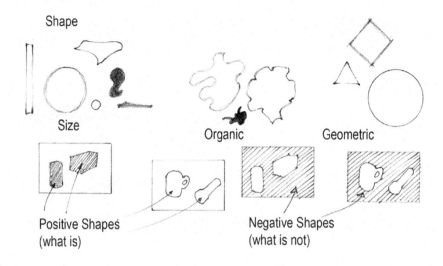

VALUE

The quality of light and dark.

Characteristics: range, intensity, contrast

Value's intensity, density, a fullness of range and the distance between the lightest value and the darkest value.

Types of Value

Solid Value

Shapes comprised of one value.

Transitional Value

Value that has a gradation from light to dark, range.

Contrasting Value

The relationship of the values to one another. Contrasting values can be very subtle (low contrast) with very little difference or they can be very pronounced (high contrast).

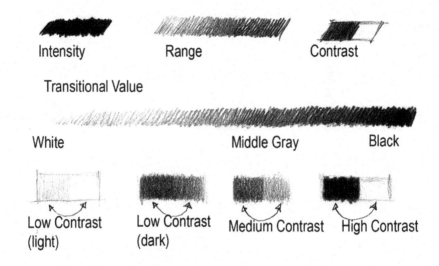

Intensity Range Contrast

Transitional Value

White Middle Gray Black

Low Contrast (light) Low Contrast (dark) Medium Contrast High Contrast

FORM/SPACE

The illusion of a three-dimensional presence

Note:

In Art the word Form can have a variety of meanings. It is used here to describe the illusion of volume, drawing three-dimensional illusions.

Characteristics: size relationship (harmony, contrast), nature (organic, geometric)

Types of Form

Positive Form

The three-dimensional definition of what is, Positive Form is the illusion of the things of substance.

Space (Negative Form)

The three-dimensional definition of what is not, Negative Form is the **Space** that exists around, within, and between the things of substance. It is the Space between this and that or the Space from here to there. Space is the emptiness that makes a room, a room.

Size
(harmony)

Size
(contrast)

Organic Form
(harmony)

Geometric Form
(harmony)

Form Contrast

Positve Form
"what is"

Negative Form
"what is not"

Emptiness

Note:

Positive and Negative Form have a direct relationship to Positive and Negative Shape. In a two-dimensional drawing Shape defines an actual two-dimensional area while Form is an illusion of the third dimension drawn on a two dimensional surface.

TEXTURE

The three-dimensional quality of surface.

Texture is unique among the drawing elements because, besides creating its illusion in the drawing, the drawer must consider the actual texture of the surface that is being drawn on.

Characteristics: degree (light, medium, heavy)

Texture
(variation)

Light Texture

Medium Texture

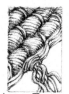
Heavy Texture

PATTERN

Note:

Pattern is technically not one of the visual elements and it is generally considered a repetitive design that has a discernible order. It is, however, for learning purposes, very useful for Pattern to be considered as an element and to modify its definition to any shape or marking that conforms to the surface it is on, repetitive or not.

Pattern can then be as deliberate as a decorative design (repetitive or not), as readable as a product logo, or as accidental as a stain.

Characteristics: size, shape, value, color, nature (organic, geometric)

Note:

Because Pattern conforms to the surface it is on and because that surface is defined by its Form and its Texture, Pattern is always under the influence of the Texture and the Form.

Types of Pattern

Basic Pattern
A series of ordered and repetitive shapes.

Logos and singular images
A designed shape, images, lettering or a combination of these.

Stains and other accidental marks
All types of pattern conform to the surface they are on.

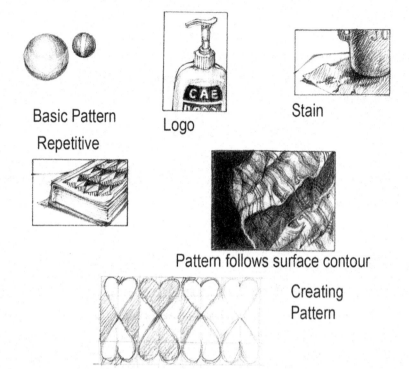

Basic Pattern
Repetitive

Logo

Stain

Pattern follows surface contour

Creating
Pattern

COLOR

Light that has been broken, separated, and mixed.

Note:

Color is the most complex of the Elements because it is light and light is the basis for our vision. The beginning drawer need only be concerned about two aspects of color: Color with respect to its hue, value, intensity, and Color's narrative application.

Characteristics: hue, value, intensity

Narrative Color

Color that suggests an emotional response. Color used to emphasize or separate aspects of the image.

Warm/Cool Colors

Although there are psychological theories about specific colors, the basic emotional response to color is based on its warmth or coolness. Color warmth suggests an emotional empathy and coolness suggests less, or the lack of it. In general, cool colors are those that are closest in hue to blue and warm colors are those that are closest in hue to red.

Note:

Emotional response to color, like all emotional responses, is not a formula, it is a potential.

Reference Tab #2
Devices for Seeing Proportion and Placement

Proportion is the observed size relationship of things to themselves, to the things around them, and to the space they occupy. Placement is the position that the subject matter takes with respect to each other on the picture plane.

There are a variety of techniques and devices that can help one to see and translate proportion and placement in a drawing. They function as tools for evaluating what is actually being observed.

Note:

Draw what you see, not what you think you know.

Proportion involves three separate issues of size. There is the way that different aspects of the same object relate to each other, say the width to height, there is the way one object relates to another based on its placement, and there is the relationship the objects have to the space around and between them. The following principles and techniques will aid in the understanding of these issues.

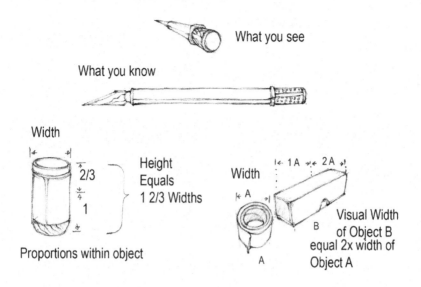

What you see

What you know

Width

2/3
1

Height Equals 1 2/3 Widths

Proportions within object

Width

1A 2A

A

B

A

Visual Width of Object B equal 2x width of Object A

Note:

Understanding these principles of seeing proportion and place-ment are crucial to drawing accurately.

Point of View

In order to draw accurately, what is being observed, the drawer must maintain a consistent point of view. That means, to the extent possible, maintaining and coming back to a consistent line of sight. Even the slightest change in point of view alters the way the drawer sees the subject matter.

Maintain a consistent Point of View

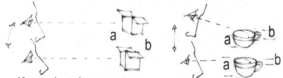

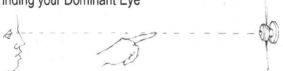

If your head moves to the right side a becomes smaller and side b becomes larger and visa versa

If your head moves up b becomes bigger while a becomes smaller and visa versa

Finding your Dominant Eye

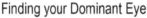

With both eyes open sight down your finger so that it covers an object or a spot

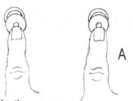 A

 B

With both eyes open you will appear to be looking "through" your finger

Shut one eye, if your finger stays on the object (A) the open eye is dominant. If it jumps (B) then the other eye is dominant.

Your Dominant Eye

Each of us has a dominant eye. That means that one eye takes precedent over another in certain functions. One of these functions is sighting. For example; an archer who is right eye dominant will shoot most comfortably right handed and an archer who is left eye dominant will shoot most comfortably left handed. But mix those up and the procedure becomes quite awkward. The same issue applies with the sighting techniques we will employ in order to see proportion and placement.

In order to establish your dominant eye, with both eyes open aim your index finger at an object or spot that is a ways from you. You will

be able to see the object as though you are looking through your fingers. Close one eye and your finger will either block your view of the object or jump off it. If your finger covers the object, the eye that is open is your dominant eye. If your finger jumps, try it with the other eye open, closing the one that was first open, and your finger should then cover the object. The open eye is your dominant eye.

Note:

It is possible to use these techniques without knowing your dominant eye. You just need to keep one eye closed. If you are right handed and close your left eye, and if you are left handed and close your right eye, you probably are using your dominant eye.

Thumb to Pencil Technique

It is an artistic cliché, the artist with a vertically held pencil sighting down a point marked on the pencil by the thumb, and as it is with most clichés, there is a truth to it. Since artists became interested in drawing accurately they have used this technique as a very effective way to understand observed proportion.

A pencil is held vertically in a pistol grip with the arm extended a comfortable distance. (This distance, between the eye and the pencil, cannot change throughout the measuring process or the measurements will not be in proportion to one another.) The dominant eye sights down the top of the pencil to a point on the object, say the edge of the object, keeping the pencil top on that point the eye finds another point on the object (the other edge) and the drawer slides the thumb to that sight line. This gives the drawer a measurement (the width of the object) that can be used (keeping the same eye to pencil distance) to measure other distances in relation to the one measured. (In this case the number of widths in the height and so on.)

Establishing Visual Proportions

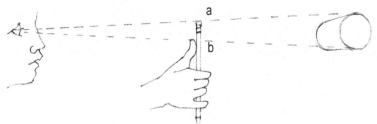

Close one eye and with your dominant eye align the top of your pencil (a) with one aspect of your object, in this case its width, move your thumb to a position (b) that registers the visual distance. a to b

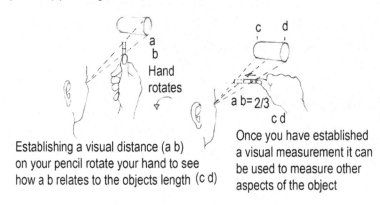

Establishing a visual distance (a b) on your pencil rotate your hand to see how a b relates to the objects length (c d)

Hand rotates

a b= 2/3

Once you have established a visual measurement it can be used to measure other aspects of the object

The distance between your eye and the pencil must remain the same throughout all the measuring.

Horizontal/Vertical Pencil Reference

A pencil held in a horizontal or vertical sighting position gives the drawer a reference to the edges of the picture plane. The horizontal position of the drawer's pencil correlates with the horizontal (top and bottom) edge of your picture plane. The vertical pencil position correlates with the vertical (left and right) edge of your picture plane. When the pencil is held in a horizontal or vertical position and moved to a sighting position that visually "touches" an edge of the subject matter, it allows the drawer to see the angles involved. In that way the angles can be accurately translated to the picture plane.

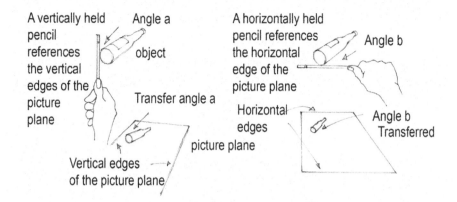

A vertically held pencil references the vertical edges of the picture plane

Angle a

object

Transfer angle a

Vertical edges of the picture plane

A horizontally held pencil references the horizontal edge of the picture plane

Angle b

Horizontal edges

picture plane

Angle b Transferred

A View Finder

A view finder is simply a device to look through. Like the view finder on a camera it creates a small window through which one views the subject matter. A view finder can be made in a variety of ways. The opening needs to be small enough so that one can see all edges without moving your eye. When making your own, it is important to make it out of a paper stock that is stiff enough to hold its shape when held with one hand at its corner. The opening must have proportions that correlate with those of the drawing's picture plane.

Note:

In order for the view finder to work as a compositional tool and drawing aid, it needs to have an opening that corresponds to the shape and proportions of the drawing's picture plane.

The View Finder and drawing "What is not"

Drawing "what is not" is drawing the negative shapes that exist, around and between the subject matter. Focusing on the negative shapes allows the drawer to concentrate on the actual shapes as they appear and is a good way to break down any preconceived notions that one may have with respect to visual properties of the subject matter. A view finder, by establishing the image's edges, helps isolate the negative shapes. It can also be used as a tool that "magnifies" by isolating, a particular segment of the subject matter.

Using a View Finder for Horizontal/Vertical Reference

As a horizontal/vertical reference a view finder is used in a similar manner to the pencil, with the added benefit that it can give both a vertical and horizontal reference at the same time. This double reference can often clarify a difficult drawing problem.

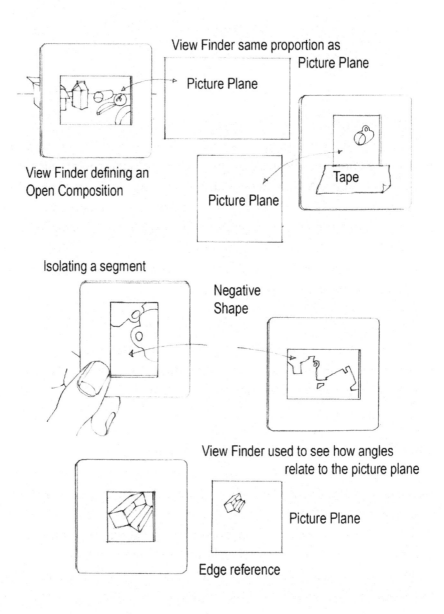

View Finder same proportion as Picture Plane

Picture Plane

View Finder defining an Open Composition

Tape

Picture Plane

Isolating a segment

Negative Shape

View Finder used to see how angles relate to the picture plane

Picture Plane

Edge reference

Reference Tab #3
Compositional Considerations
for Visual Weight

Composition in a drawing is the way one arranges what is drawn (the positive shapes) and what is not drawn (the negative shapes). A drawing is two-dimensional. The third dimension (form and space) is an illusion that is created in the two-dimensional shapes and values, therefore the discussion of visual weight is made in terms of shape and value. Balance, the visual sense of a stable image, in a composition is achieved by the way one considers and uses the following factors of visual weight: Size, Quantity, Complexity, Edge, Direction, and Intensity.

Note:

Positive shapes, because they have substance (what is drawn) are visually heavier than the negative shapes.

Size

The larger a positive or negative shape is, the greater its visual weight.

Quantity

The more there are of anything, the greater its visual weight.

Complexity

A shape's complexity is defined by its configuration, texture, pattern, coloration, and or by how much detail describes it. The more complex the positive and negative shapes are the more attention they demand. The more attention a positive or negative shape receives the greater its visual weight.

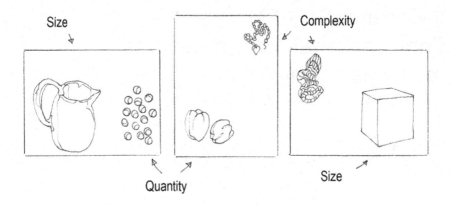

Edge

The way the positive and negative shapes interact with the edge of the picture plane determines visual weight in several ways.

Harmony

When the edge or edges of the positive or negative shape are parallel, or near parallel, to the edge of the picture plane the harmony develops visual weight.

Contrast

Visual weight is developed when the edge or edges of the positive or negative shapes are in contrast to the edge of the picture plane.

Note:

In both contrast and harmony, the closer the edge of the shape is to the edge of the picture plane, the more tension is developed. The tension increases the visual weight.

Breaking the edge

The greatest amount of visual weight occurs when a positive or negative shape is positioned in the composition in a way that suggests that it goes beyond the picture plane. A shape that breaks the edge has both the visual weight of the drawn shape as well as the weight of the

part that is off the page and only suggested. The viewer is seeing one and creating the other. Weight is also created by the tension that occurs where the shape intersects and leaves the edge of the picture plane. It is almost like nailing the image to the wall at that point. This always occurs to some extent in an Open Composition.

Note:

An Open Composition occurs when any part of the image "breaks" the picture plane. This is always true when one creates an image that is a segment of a whole. In a Closed Composition all the positive and negative shapes are contained within the picture plane.

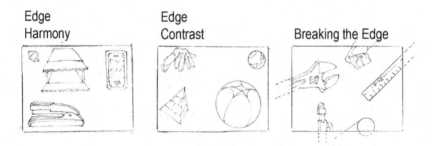

Edge Harmony Edge Contrast Breaking the Edge

Direction

With direction the visual weight is developed by the way one's placement of the positive and negative shapes direct the viewer's attention around the drawing. This movement is achieved by alignment and by directional subject matter.

Alignment

Alignment occurs when the positive or negative shapes align in a manner that produces a sight line from one edge to another. The sight line creates a visual path for the viewer to follow.

Directional subject matter

Subject matter that "points" because of what it is or how it is shaped gives the viewer, consciously or unconsciously, a lead to follow.

Intensity

Intensity is like volume in speech, the louder the more attention and thus more weight. In drawing that intensity occurs in two ways, through value (lightness and darkness), and color. The darker a value is, and the more saturate a color is, the greater its visual weight.

Direction

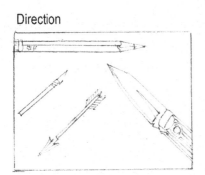

Intensity

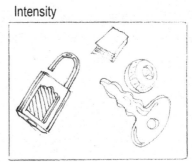

Reference Tab #4
Rendering the Illusion of
Three- Dimensional Form

Rendering is the process of creating, in value (light and dark) with or without color, the three-dimensional illusion of what is being seen or invented. It is the creation, on a two-dimensional surface, of an illusion of three-dimensional Form and Space and characteristics that make each specific.

In drawing, the illusion is created by the gradation of value (light to dark) and it is accomplished by the use of one of the value-in-transition marking systems (Scumbling, Blending, Cross Hatching, and or Stippling). These systems work because when the human eye perceives an image there is a tendency for the light areas to advance (move forward) and for the dark areas to recede (fall back). In drawing, this means that when a light area gradually moves to a dark area it creates the illusion that the light area is going back in space. The rate of the transition (how fast it moves) from light to dark develops the speed at which the

area appears to move back in space. The faster the light area becomes dark, the greater the degree of turn in the curve or angle.

In rendering, there are three issues for consideration: Form, Light and Pattern. And although they are worked together, during the drawing process one must keep them in mind as separate issues. That is, at any given moment, it is important for the drawer to know which one, Form, Light, or Pattern is being considered.

Note:

Form, Light, and Pattern are in fact interconnected and one must develop them together in the drawing. They are however separate issues and the drawer must make different considerations with each while merging them into a cohesive image.

Form

Creating the illusion of Form is the first consideration in rendering, not because it is any more important than the other two. Form is, however, the most elusive because one is drawing a three-dimensional world on a two dimensional surface. Making the illusion of Form on that two dimensional surface requires that the three-dimensional illusion is continually being reinforced. There are drawing situations where one does not, in fact, see the three-dimensional quality of the subject matter because of the way it is lit or obscured by the Pattern. In those cases the Form becomes an intellectual understanding not a visual observation and the drawer must remember that while drawing a dominant Light effect or a strong Pattern, the illusion of Form must also be created. Form is fundamental to Light and Pattern, it is the basic structure that determines the shape of light and pattern as it is also the surface they exist on.

The rendering of Form is a process of creating the value transitions from the **Light Value** through the **Middle Value** to the **Darkest Value**.

Light

Light is the source of sight and drawing what is observed requires some basic understandings about how Light interacts with the things that it illuminates. When considering Light, one begins with source. Light

always emanates from its source, and is reflected in straight lines. This principle is made more complex by multiple sources and reflected light, although the basic principles remain true. In complex lighting situations it often requires that one determine the sources in order to better understand the way they are effecting the subject matter. For the beginning drawer it is best, when possible, to work with a single source in order to get a basic understanding of light and how it effects illusion and rendering. Light produces four basic effects: **Highlights**, **Mid-tones, Reflected Light**, and **Shadows** on Form. This understanding is crucial to rendering.

Pattern

Pattern is often the most apparent of the three. Logos, designs, and stains are almost always, either by intent or accident, the first thing that is seen. Precisely because of this, in rendering, the considerations made in drawing Pattern must fall under the influence of those made when rendering Form and Light.

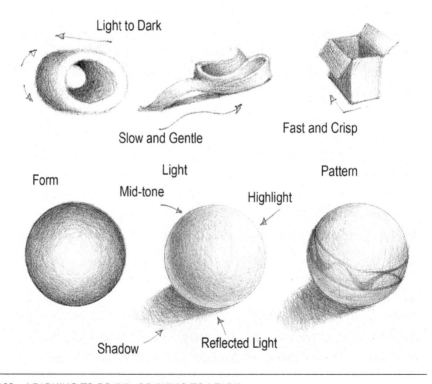

Light to Dark

Slow and Gentle

Fast and Crisp

Form

Light

Mid-tone

Highlight

Pattern

Shadow

Reflected Light

Reference Tab #5
Creating the illusion of
Three Dimensional Space

In order to develop the illusion of three dimensional space (naturalistic space) on a two dimensional plane one must understand a few basic principles of sight. Visually we perceive space in four ways: **Overlapping, Linear Perspective, Atmospheric Perspective,** and **Picture Plane Placement**. It is important to remember that these principles are based on an understanding of the way we see. They are not telling one what to see, they are interpreting what is seen.

Note:

We see three dimensionally. If you draw accurately what you see you will create the illusion of three dimensional space.

Whereas this statement is true, to do so requires a couple of considerations that are quite different from the way we actually experience our moments visually. In life we are seldom in a fixed position. We shift our heads and move our bodies constantly while our eyes move from one thing to another in a continual refocusing.

Note:

To draw accurately one must maintain a consistent point of view (fixed head position and eye focus).

Picture Plane Placement

In Naturalistic Space the Picture Plane is like an open window. The way we look through that window, our point of view, establishes the images' spacial arrangement. Our normal orientation to the physical world places the Background in the middle of the Picture Plane, the Foreground at the top and bottom, with the Middle Ground in between. When we look up or down, changing our point of view, we shift the Picture Plane Placement accordingly.

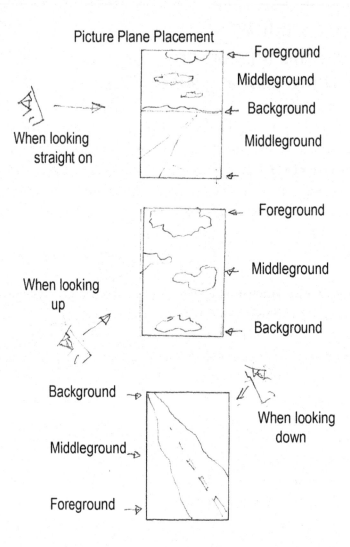

Picture Plane Placement

When looking straight on

Foreground
Middleground
Background
Middleground

When looking up

Foreground
Middleground
Background

Background
Middleground
Foreground

When looking down

Overlapping

Overlapping occurs when our point of view makes one thing appear in front of another.

Atmospheric Perspective

Atmospheric Perspective refers to clarity. The farther something is away from us the less clear it appears, the detail become less and its presence diminishes.

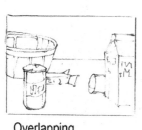
Overlapping

Atmospheric Perspective

Linear Perspective

Linear Perspective

Linear Perspective defines three basic principles of sight. First, the farther something is away from us the smaller it appears. Second, the rate at which the object is visually getting smaller is consistent and knowable. Thirdly, there is a physical limitation to how far one can see. Linear Perspective can be a very complex in-depth study, but that complexity is not needed in order for one to draw accurately.

However there are a few basic principles that can help one to interpret and draw what is being seen

Note:

It is important to remember that perspective is a means of helping one to understand observation. If you draw accurately what you see (using the visual devises for seeing proportion) (reference tab #2 page 170) **you will draw in perspective.**

Eye Level

Eye level is the horizontal line that corresponds to the physical position, a fixed position, of your eyes when you are looking at a scene. If you step up on something, the position of your eyes, and eye level, go up, if you sit down the position of your eyes, and eye level, goes down. Once the position of your eyes establishes eye level they must stay in that position or it all changes. Eye level is not to be confused with where you are looking. If you are looking up or down, but you are in a fixed

position, your eye level is still the physical position of your eyes and not where you are looking.

Point of View

Point of view determines how much of your image will be above your eye level and how much will be below eye level. If you look straight ahead and you place your eye level in the middle of your picture plane, you will have an even split between the plane above your eye level and the plane below your eye level. When you look up or down your eye level does not change (the physical position of your eyes has not changed) but the picture plane moves up or down to accommodate the point of view. In some images the eye level is not on the picture plane but above or below it. Eye level and point of view should not be confused, they are related but they are not the same thing.

Visual Limitation

The human eye can only see so far. As things go away from us they appear smaller and smaller until they are so small that we cannot see them. The point at which they disappear is the limit of our sight, it is as far as we can see. Consider that limitation as a wall that is out in front of you and no matter where you look you cannot see farther than that wall. A physical limit is a physical limit.

Vanishing Point

Consider the standard railroad tracks going back in space. They look smaller and smaller until they are no longer parallel and become a point. That is the vanishing point for the tracks and it is a definition of your visual limitation, it has reached the "wall." Now couple that with your eye level. If you were standing on the Great Plains with flatness all around you, and the tracks stretching out before you, you would find that your eye level and the horizon line would be the same and the railroad tracks would have a vanishing point on your eye level. If you could see the mountains in the distance, then the horizon line (the

mountain tops) would no longer correspond to your eye level, but the tracks would still have a vanishing point on your eye level.

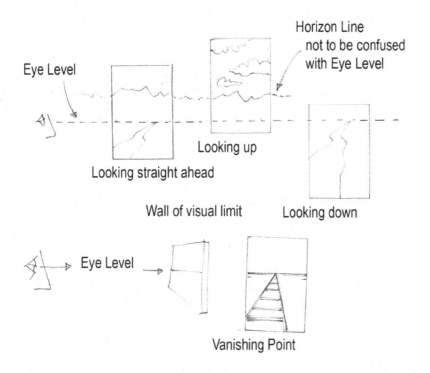

Parallel Lines

Although we know the two rails that make up the railroad track are parallel, they appear to come together at the same vanishing point, at a "wall" that defines the physical limit of our vision. This visual principle simply stated is that all lines that are parallel, vanish to the same point.

Note:

To find the vanishing points for depth or width, using the observed angle, the receding line is extended until it meets eye level. Where the line meets eye level establishes the vanishing point, i.e. the vanishing point for all lines that are parallel to that line. You can determine the angle of the initial receding line by using your pencil or a view finder.

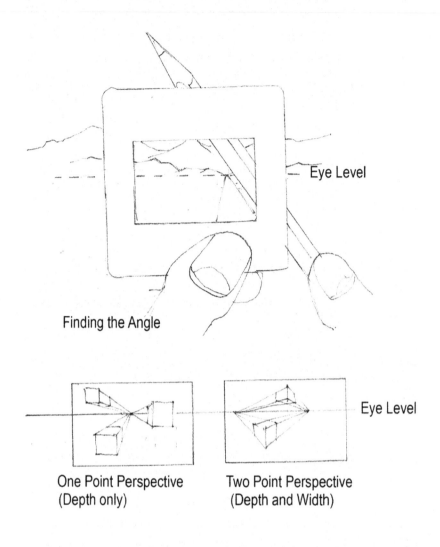

Finding the Angle

— Eye Level

Eye Level

One Point Perspective
(Depth only)

Two Point Perspective
(Depth and Width)

One, Two, and Three Point Perspective

Three dimensional form and space are defined by three features: depth, width, and height. In one point perspective, only the depth is receding to a vanishing point. In two point perspective, the depth and width are each receding to their individual vanishing points. In three point perspective, the depth, width, and height are all receding to their individual vanishing points.

We, of course, see in three point perspective, although in most of our observation the height of the things we are looking at is changing

so little that it is imperceptible. For the beginning drawer a simple understanding of one and two point perspective is more than adequate.

Note:

When one draws accurately what is seen, one draws in perspective.

One point perspective is helpful in understanding and drawing an image where the point of view is close to the center. A head on image can be developed with only a receding depth. If the point of view moves far from center the image become noticeably distorted.

Most of the time two point perspective works to help define our observations and it generally provides enough basic structure for an invented space. In two dimensional perspective the height is always considered to be perpendicular (straight up and down). It assumes that the height is receding so slowly that it is imperceptible, with the height as a constant perpendicular and the depth and width, receding. Two-dimensional perspective defines a three dimensional form.

In two dimensional perspective a basic box is a three dimensional form that can be readily drawn. A box of the right size and shape can hold anything. When it is a problem understanding the perspective on a particular subject matter, it can be helpful to draw the box that would fit it in perspective, and then draw it in the box.

Inclined Planes

Consider the horizontal plywood planes again. They form the tops and bottoms of a box. The depth and width are receding to vanishing points that are on our eye level at the wall (the limit of our vision). An inclined plane is a horizontal plane that is tipped up or down. When a horizontal plane is tipped up or down (an inclined plane) its vanishing point will simply go straight up or straight down the wall.

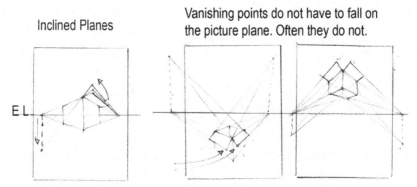

Inclined Planes

Vanishing points do not have to fall on the picture plane. Often they do not.

E L

The flap on a box is an example of an Inclined Plane.
The flap is an extension of one of the box's planes and thus its vanishing point will move up or down the "wall" from the same point on eye level as that plane.

Finding Center

Finding center on a rectangle that is drawn in perspective is just like finding center on one that is not in perspective. You draw the two opposing diagonals corner to corner and where they cross is optical center. A line from this optical center point that is drawn to the same vanishing point as the lines it divides will divide the plane they describe into optical halves. This can be repeated to find smaller divisions.

Finding center can also help you to draw circles that are in perspective. A circle fits into a square and in the same way a circle in perspective will fit into a square that is in perspective. This is particularly helpful with cylinders.

Dividing Space

When observing or inventing space, perspective can help one to understand how to draw a receding and evenly divided space as it recedes. In one point perspective, as in a fence, when you want to draw the receding space as it occurs from one post to another, you begin by drawing the first post. The first post is drawn as you see, or invent, it in its relationship to the rest of your composition. A line that defines the top and the bottom of the posts is extended to their vanishing point (where they cross your

eye level). The distance between the first post and the second is either observed or invented and it will govern the rate of reduction. A line is then drawn from the center of the first post and extended to their vanishing point. (Parallel lines have the same vanishing point.) A diagonal line drawn from the top of the first post through the center of the second post will give you the location of the bottom of the third post and so on. This basic principal of division can be applied horizontally and vertically.

Using Linear Perspective to help understand what is seen

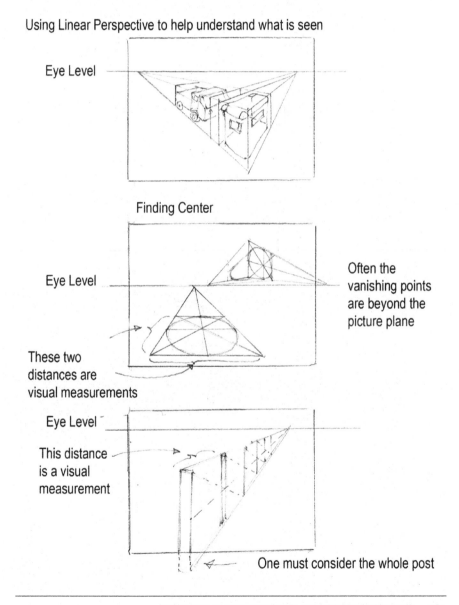

Eye Level

Finding Center

Eye Level

Often the vanishing points are beyond the picture plane

These two distances are visual measurements

Eye Level

This distance is a visual measurement

One must consider the whole post

Note:

Linear Perspective can seem very confusing. If you do not "get" it, draw what you see using the devises for seeing proportions. If one draws accurately what is seen, one will draw in perspective.

Lightning Source UK Ltd.
Milton Keynes UK
UKOW01f0242040817
306667UK00001B/72/P